TO MUM AND DAD — WITH LOVE

ART LIFE

MAKE AMAZING ART AND

UNLOCK YOUR CREATIVITY

BEV SPEIGHT

An Hachette UK Company
www.hachette.co.uk

First published in the United Kingdom in 2017 by ILEX,
a Division of Octopus Publishing Group Ltd
Octopus Publishing Group, Carmelite House,
50 Victoria Embankment, London, EC4Y 0DZ
www.octopusbooks.co.uk
www.octopusbooksusa.com

Distributed in the US by Hachette Book Group
1290 Avenue of the Americas, 4th and 5th Floors
New York, NY 10020

Distributed in Canada by Canadian Manda Group
664 Annette St, Toronto, Ontario, Canada M6S 2C8

Publisher: Roly Allen
Editorial Director: Zara Larcombe
Managing Specialist Editor: Frank Gallaugher
Editor: Rachel Silverlight
Art Director: Julie Weir
Designer: Bev Speight
Production Controller: Meskerem Berhane

ISBN 978-1-78157-407-2

A CIP catalogue record for this book is available
from the British Library

Printed and bound in China

10 9 8 7 6 5 4 3 2 1

CONTENTS

THE ART LIFE JOURNEY

ART LIFE IS AN INVITATION TO TAKE A JOURNEY INTO THE INTRICACY, COLOUR, TEXTURE, FORM AND QUIRKINESS OF WHAT'S AROUND YOU.

NO CONSTRAINTS, NO PRESSURE, NO EXPECTATIONS. RATHER THAN FOLLOWING A RIGID PROJECT PLAN, ENJOY THE ELEMENT OF SURPRISE AND SATISFACTION IN MAKING ART THAT EVOLVES IN THE WAY YOU WANT.

LOOKING BEYOND THE OBVIOUS, THE IMMEDIATE, THE FIRST IDEA THAT SPRINGS TO MIND, ART LIFE GUIDES YOU TO BE INSPIRED BY THE ENVIRONMENT IN WHICH YOU LIVE AND, FROM THIS, TO DEVELOP FANTASTIC IDEAS.

GIVEN THE FREEDOM TO THINK, AND ALLOWING YOUR IMAGINATION TO FLOW, YOU'LL DISCOVER YOUR CREATIVE DIRECTION.

I HOPE YOU ENJOY IT.

FOUR JOURNEYS

LINE

BOOK

TRACES

PAPER

EACH JOURNEY (OR CHAPTER) HAS A CREATIVE STARTING
POINT WITH EXCITING EXAMPLES TO ILLUSTRATE AND INSPIRE.
VISUAL SIGNPOSTS WILL GUIDE YOU ALONG THE WAY. THE PATH
IS FLEXIBLE AND CAN BE TAKEN IN DIFFERENT DIRECTIONS
SO YOU WILL DEVELOP IDEAS THAT ARE UNIQUE TO YOU.

ART LIFE PRESENTS A BROAD SELECTION OF IDEAS AND
DISCIPLINES – THE LINE CHAPTER EXPLORES DRAWING WITH
MIXED MEDIA; BOOK DEVELOPS INTO SCULPTURE; TRACES
TACKLES MARK-MAKING; AND PAPER LOOKS AT COMPOSITION.

WORK YOUR WAY THROUGH THE BOOK IN ORDER OR
CONCENTRATE ON ONE DIRECTION; COMBINE AND ADAPT
OR DEVELOP FURTHER – YOU CHOOSE.

INSPIRATION

EXAMPLE

GUIDANCE

ART INSPIRED BY LIFE

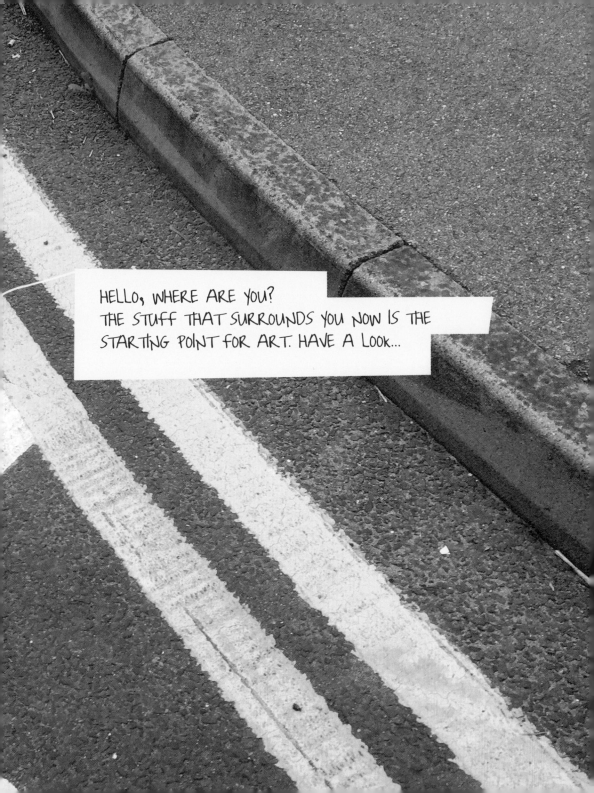

WHERE ART BEGINS

TYPEFACES ON BREAKFAST CEREAL PACKETS
TYRE-TRACKS ON A TARMAC ROAD
TREAD PATTERNS ON THE SOLES OF RUNNING SHOES
DRIFTWOOD, PEBBLES AND DEBRIS ON THE BEACH
SHAPES AND TRACES IN THE SNOW
CHARITY-SHOP BOOKTOWERS AND RANDOM ORNAMENTS
THE TORN EDGES IN NEWSPAPER STACKS
OVERLAPPING COFFEE-STAIN RINGS IN THE CAFE
PATTERNS IN SHADOWS CAST BY THE SUN
THE PSYCHEDELIC PETROL SPILL IN THE ROAD

ALL THE STUFF THAT SURROUNDS US.

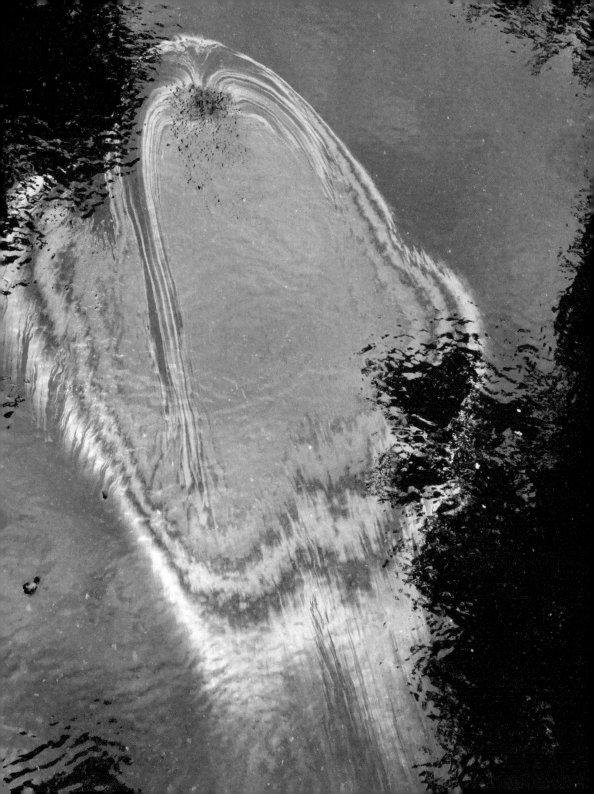

LINE

ONE THING LEADS TO ANOTHER

STARTING POINT

CREATING A CONTINUOUS LINE...

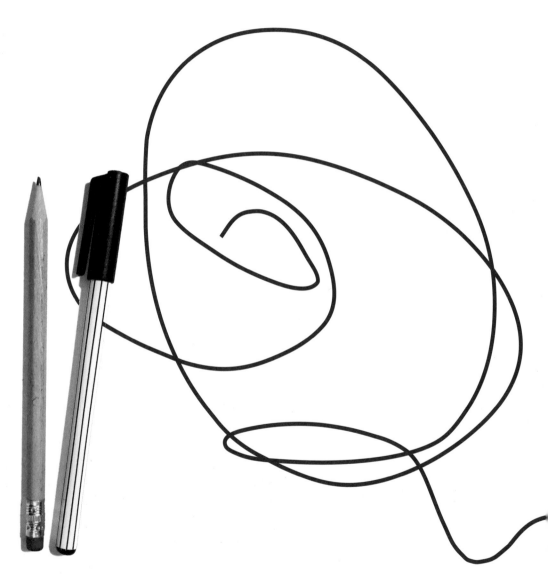

IT BEGINS WITH A JOURNEY: YOUR USUAL TRIP TO THE
SUPERMARKET, YOUR WALK HOME FROM THE TRAIN,
A TRAIL THROUGH THE WOODS WITH YOUR DOG; A BUS TRIP
OR A STROLL THROUGH THE CITY STREETS — ANYWHERE.
TRAVEL IT!

WHERE DOES YOUR LINE GO?

WALK A LINE

WALKING THROUGH THE CITY, LOOK UP TO THE SKYLINE.
SEE THE FORM OF SKYSCRAPERS, SQUAT OFFICE BLOCKS,
GLASS TEMPLES, GEOMETRIC TOWERS: NOTICE HOW BUILDINGS
CUT SHAPES INTO A FLAT SKY, THE SIMPLE AND COMPLEX
PATTERNS CAST BY LIT-UP WINDOWS, BRICKWORK, STONE
COLUMNS. YOU MIGHT NOTICE CLOUDS NESTING BY ANGULAR
ROOFTOPS, CURLY TREES BY CONCRETE WALLS, THE CURVES OF
A RIVER FLOWING BETWEEN BRIDGES, OR A BIRD IN FLIGHT...

LOOK DOWN AT ORNATE MANHOLE COVERS, METAL GRATES,
PATTERNED STONEWORK, FALLEN LEAVES, STACKS OF
UNWANTED NEWSPAPERS BOUND WITH STRING, SPRAYPAINT
MAINTENANCE INSTRUCTIONS ON THE PAVEMENT, OR THE
ALLEY CAT STALKING HIS PATCH...

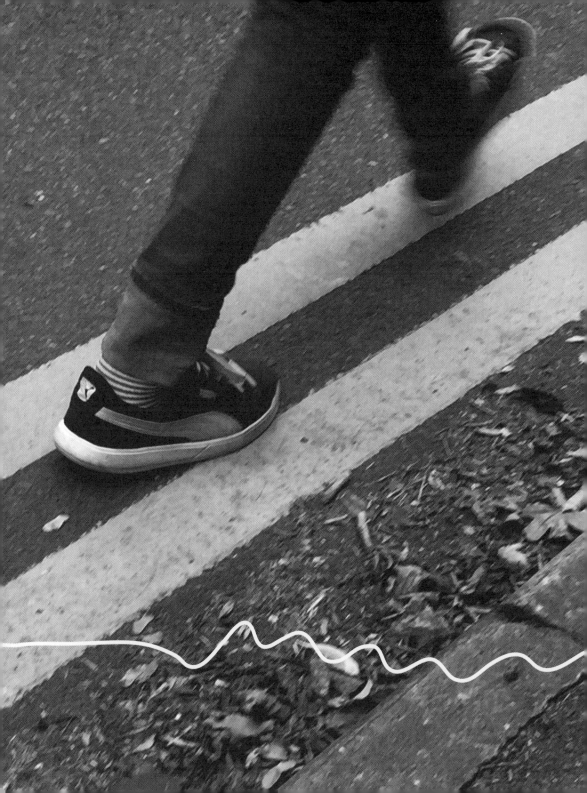

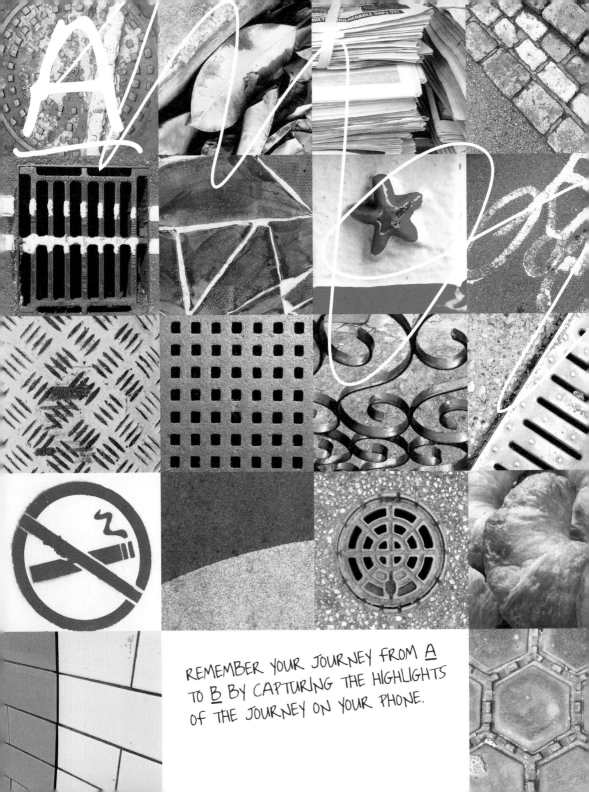

REMEMBER YOUR JOURNEY FROM A TO B BY CAPTURING THE HIGHLIGHTS OF THE JOURNEY ON YOUR PHONE.

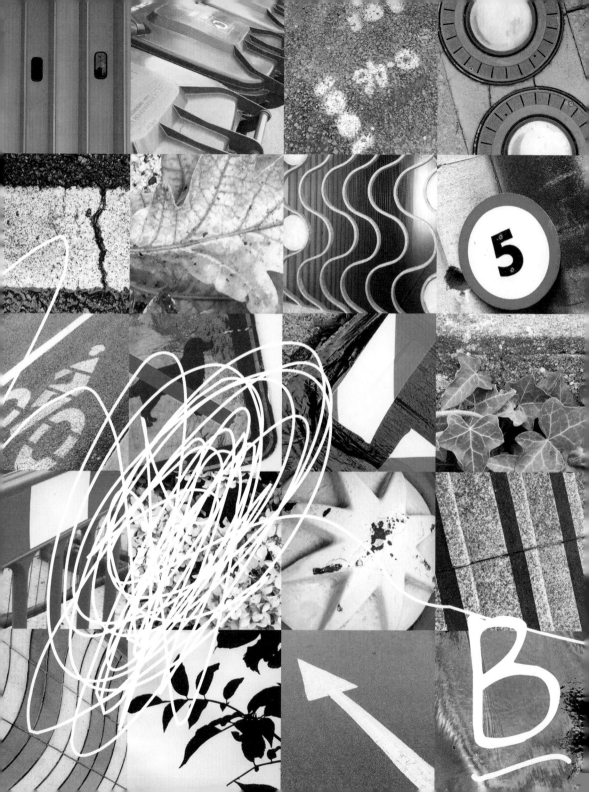

DRAW A CONTINUOUS LINE ON A PIECE OF
PAPER FROM MEMORY, DOCUMENTING YOUR
JOURNEY. DON'T TAKE YOUR PEN OFF THE
PAPER UNTIL YOU'RE DONE.

LOOK BACK AT YOUR
PICTURES IF YOU NEED
TO REMIND YOURSELF
OF YOUR ROUTE.

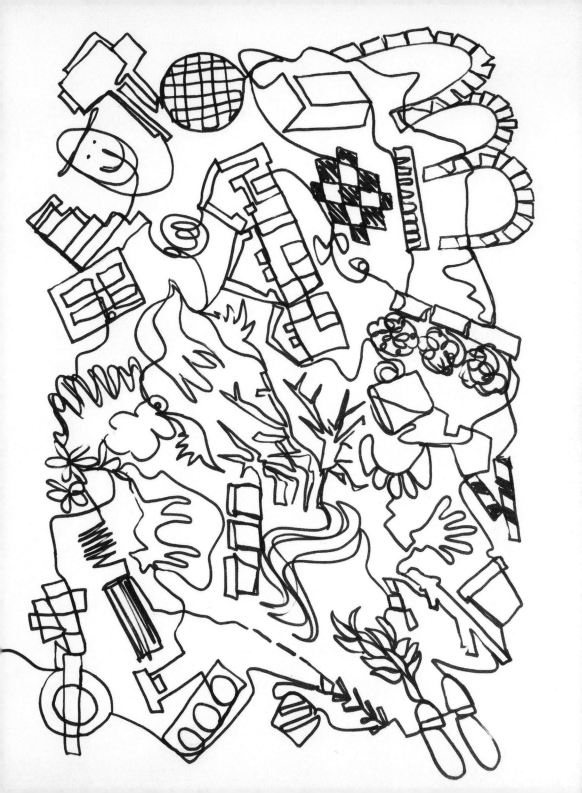

THE PAPER DOESN'T HAVE
TO BE WHITE AND THE PEN
DOESN'T HAVE TO BE BLACK.

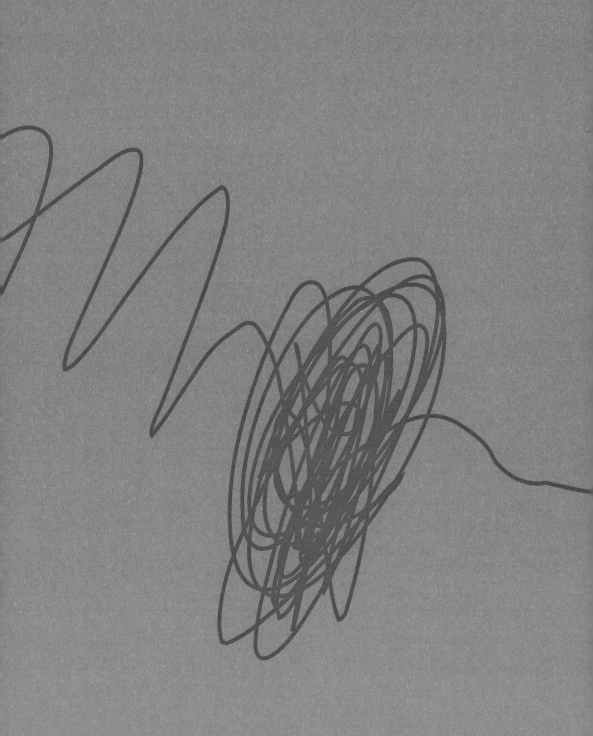

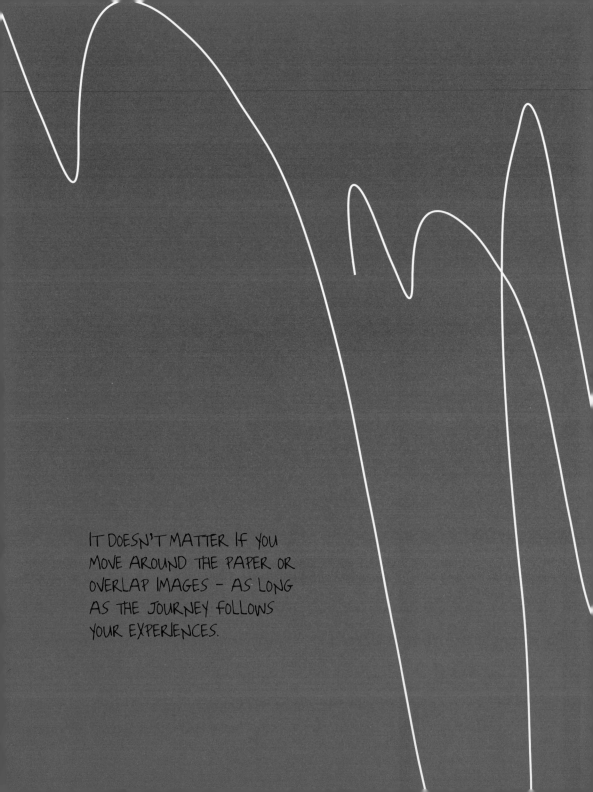

IT DOESN'T MATTER IF YOU
MOVE AROUND THE PAPER OR
OVERLAP IMAGES – AS LONG
AS THE JOURNEY FOLLOWS
YOUR EXPERIENCES.

LOOK FOR DETAILS –
CAPTURE A BIRD
IN FLIGHT. BUT KEEP
IT SIMPLE.

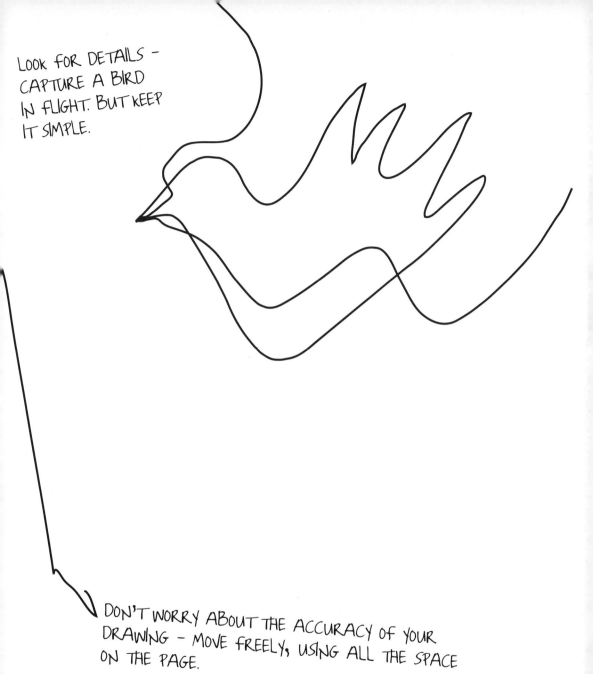

DON'T WORRY ABOUT THE ACCURACY OF YOUR
DRAWING – MOVE FREELY, USING ALL THE SPACE
ON THE PAGE.

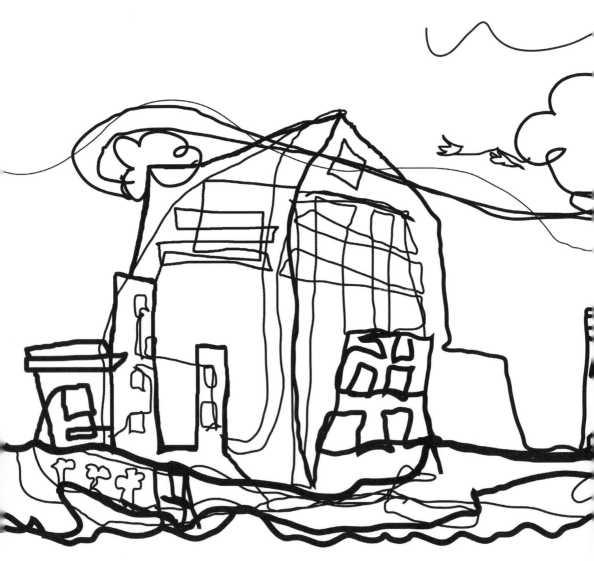

Along the Riverbank
(continuous lines)

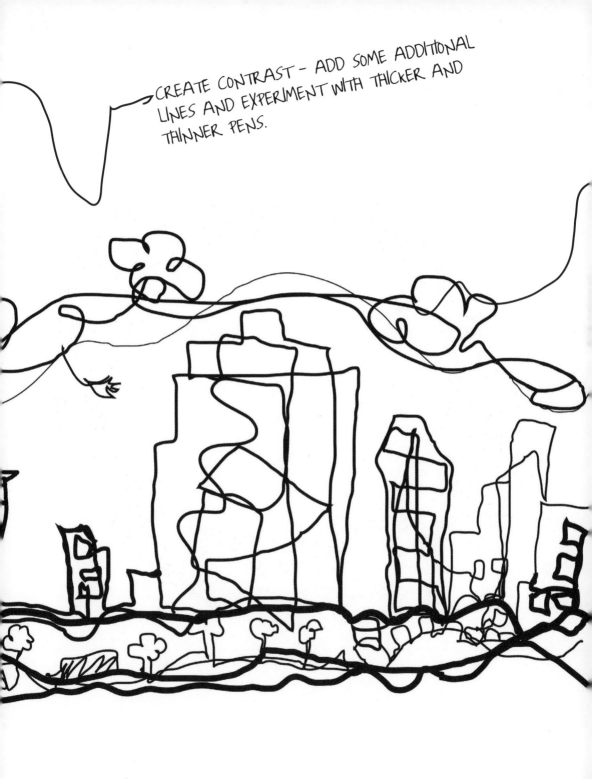

CREATE CONTRAST - ADD SOME ADDITIONAL LINES AND EXPERIMENT WITH THICKER AND THINNER PENS.

WIRE ART

RECREATE YOUR CITYSCAPE IN
WIRE. PICK UP THE DETAIL IN THE
BUILDING DESIGN, EXPLORING
PATTERN AND SHAPE.

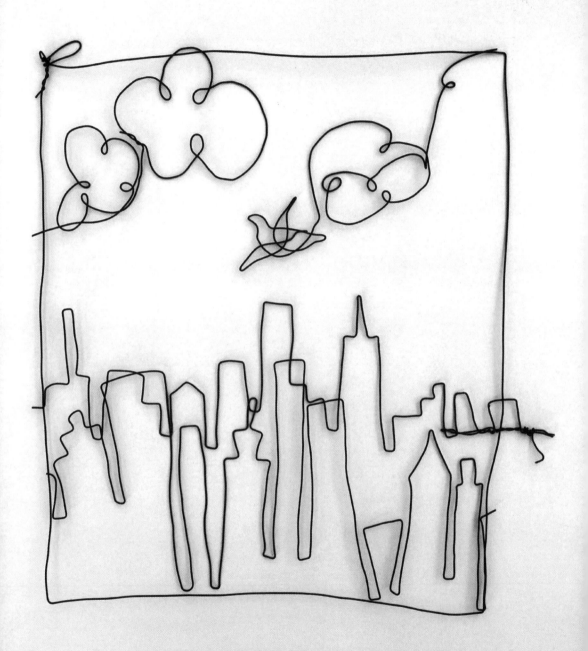

Cityscape
(wire, continuous lines)

USING ONE PIECE OF WIRE INVITES YOU TO SEE THE SIMPLICITY OF FORM.

CAPTURE AN EXPRESSION BY FOCUSSING ON TWO DISTINGUISHING FEATURES — BROWS, NOSE, LIPS, HAIR...?

OR PROGRESS TO OTHER SHAPES.

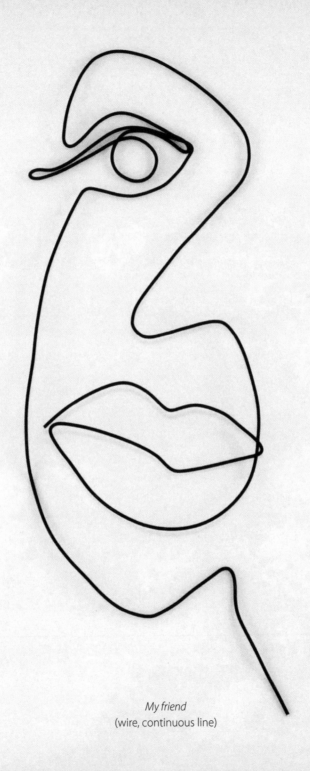

My friend
(wire, continuous line)

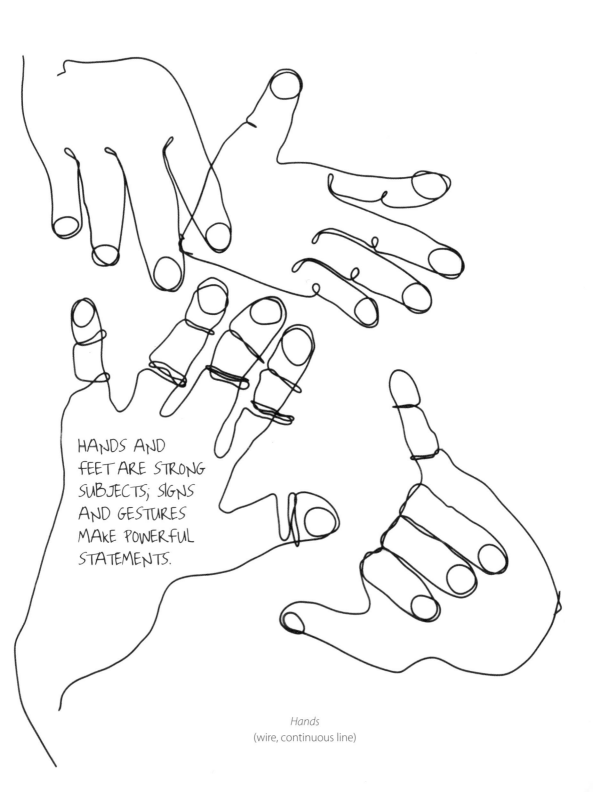

HANDS AND
FEET ARE STRONG
SUBJECTS; SIGNS
AND GESTURES
MAKE POWERFUL
STATEMENTS.

Hands
(wire, continuous line)

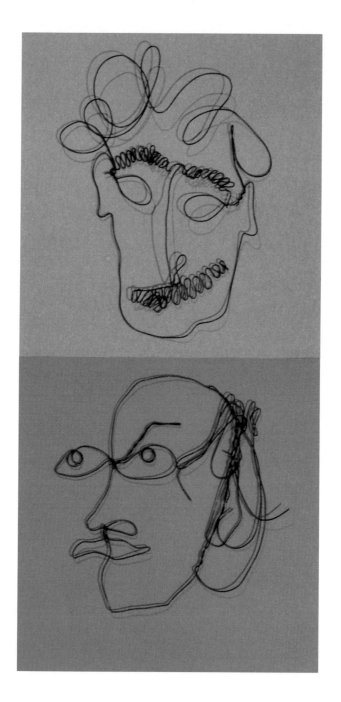

Grumpy Old Men
(wire, continuous line)

...OR PROGRESS TO OTHER SHAPES.

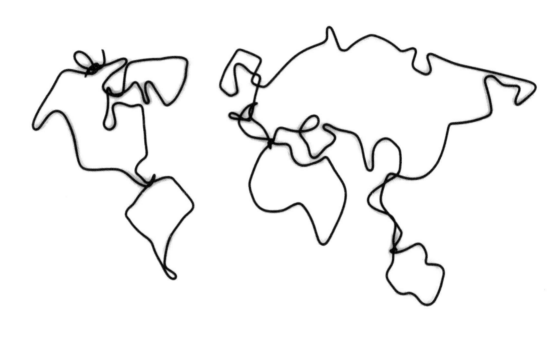

Inspiration from a tattoo
(two continuous lines)

YOU NEED VERY LITTLE EQUIPMENT TO
CREATE WIRE SCULPTURES - JUST A BASIC
PAIR OF PLIERS AND WIRE CUTTERS.

IF THE WIRE IS SOFT ENOUGH YOU CAN USE
YOUR HANDS TO MAKE THE SHAPES AND
BENDS (SEE PAGE 37).

TRY NOT TO OVER-WORK THE WIRE - IT WILL
BECOME TOO SOFT AND WAVY, LOSING ITS
SMOOTH LINE.

YOU NEED WIRE CUTTERS. DON'T
BE TEMPTED TO USE SCISSORS
AS THE WIRE WILL BLUNT THEM.

WIRE TECHNIQUES

WHEN CREATING YOUR SCULPTURE, TRY TO USE ONE LONG PIECE OF WIRE FOR THE MAJORITY OF THE ARTWORK - KEEPING IT SIMPLE. BUT FOR CERTAIN AREAS YOU MAY NEED TO ADD DIFFERENT THICKNESSES OF WIRE OR DOUBLE THE WIRE TO CREATE MORE DEPTH AND CONTRAST.

HERE ARE SOME BASIC WIRE EXAMPLES OF BENDING, SHAPING, TWISTING AND BRAIDING TO HELP YOU CONSTRUCT YOUR SCULPTURE. VARYING THE LINE HELPS ADD PATTERN AND TEXTURE.

BENDS

SHAPES

TWISTS

WRAP THE
WIRE AROUND
A PENCIL FOR A
NEAT COIL-SHAPE.

IF YOU ONLY HAVE ONE THICKNESS
OF WIRE, TWIST TWO OR THREE
PIECES TOGETHER TO CREATE
A THICKER LINE.

BRAIDS

CREATE A 3D IMAGE BY ADDING SHADOWS
TO YOUR SCULPTURE - AND THEN CAPTURE
THE RESULTS ON YOUR CAMERA.

SET UP YOUR OWN STUDIO BY MAKING A WHITE
BACKDROP FROM CARD AND USING A DESK
LAMP OR TORCH TO LIGHT IT. DARKEN THE
ROOM AND START TO EXPERIMENT WITH THE
DIRECTION OF THE LIGHT.

VARY THE LENGTH AND DIRECTION OF
THE SHADOWS BY MOVING THE LAMP
AROUND THE SCULPTURE.

VARY THE LIGHT SOURCE: FOR
EXAMPLE, HARSH LED LIGHTS GIVE
HARD, HEAVY SHADOWS. ADD MORE
LIGHTS FOR MULTIPLE SHADOWS.

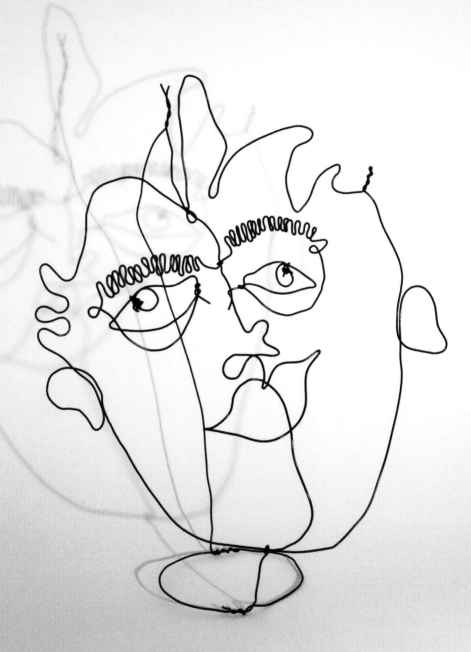

Mr Handsome
(wire, continuous lines)

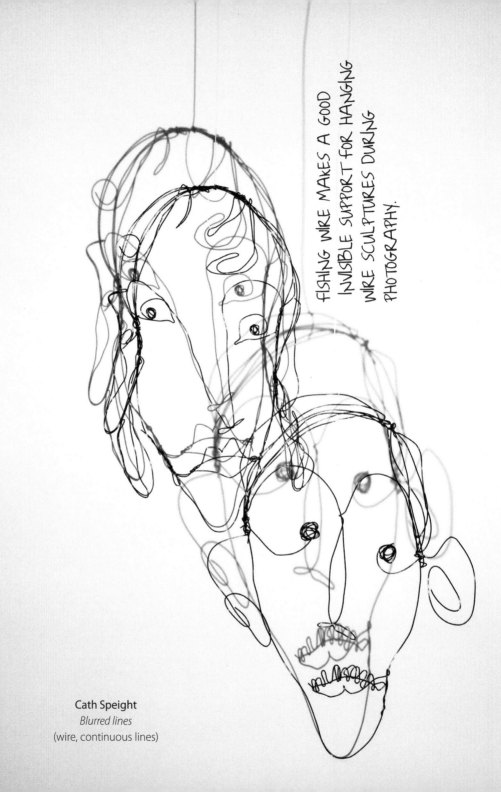

FISHING WIRE MAKES A GOOD INVISIBLE SUPPORT FOR HANGING WIRE SCULPTURES DURING PHOTOGRAPHY.

Cath Speight
Blurred lines
(wire, continuous lines)

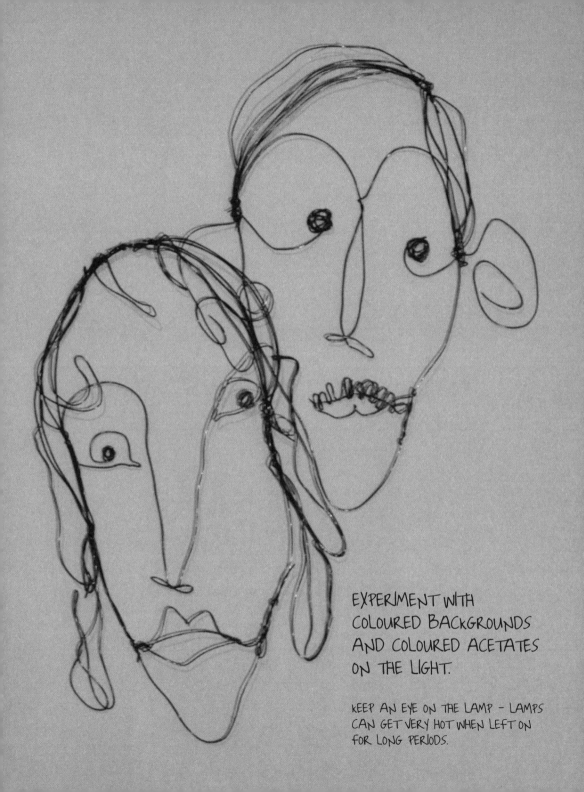

EXPERIMENT WITH
COLOURED BACKGROUNDS
AND COLOURED ACETATES
ON THE LIGHT.

KEEP AN EYE ON THE LAMP - LAMPS
CAN GET VERY HOT WHEN LEFT ON
FOR LONG PERIODS.

STRING ART

IF YOU HAVEN'T GOT ANY WIRE, WHY NOT USE STRING?

PREPARE A FLAT PAPER SURFACE, THEN DIP THE
STRING IN PVA GLUE. USE THE STRING AS YOU WOULD
THE PEN OR THE WIRE, KEEPING THE LINE CONTINUOUS
AS YOU STICK IT DOWN.

ALTERTATIVELY USE SPRAY GLUE TO LIGHTLY COAT
THE PAPER BEFORE APPLYING STRING.

OR, MAKE SOME STRING 'WIRE':
TAKE A SHEET OF CLING FILM
AND SECURE IT FLAT WITH MASKING
TAPE. SHAPE YOUR DESIGN WITH
PVA-LOADED STRING ON THE CLING
FILM. ONCE THE GLUE IS DRY,
PEEL OFF THE STRING - IT'S NOW
A PLIABLE PIECE. YOU CAN ROLL IT,
TWIST IT, ETC., THEN SECURE IT TO
FORM A 3D SHAPE.

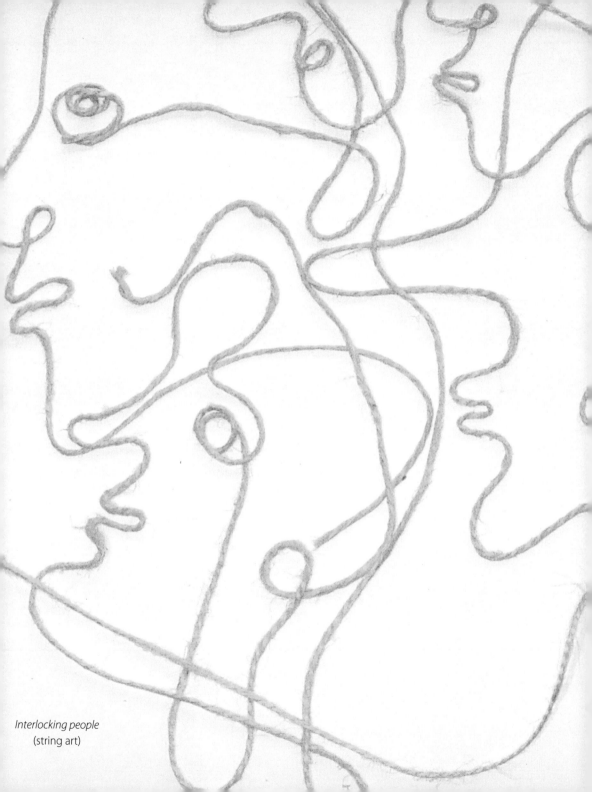

Interlocking people
 (string art)

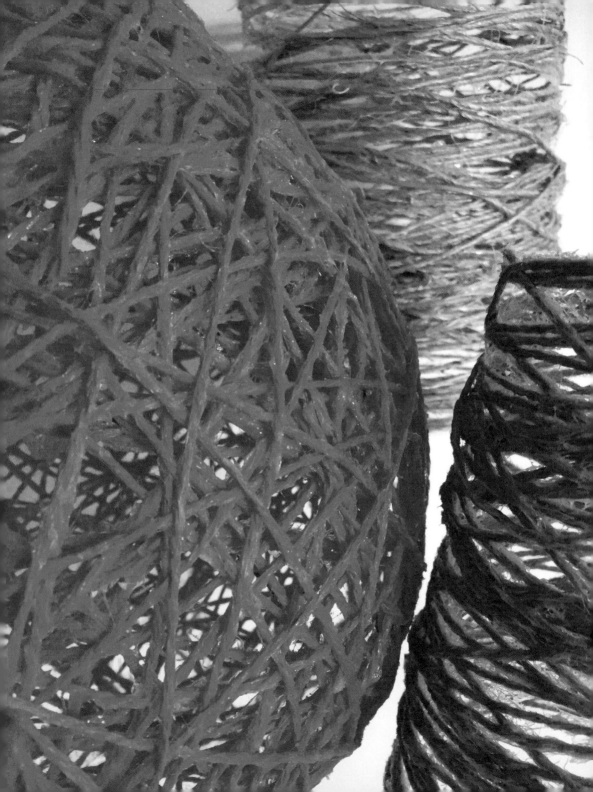

STRING SCULPTURE

FOR A STRING SCULPTURE, JUST
LOAD STRING WITH PVA GLUE AND
WRAP THE STRING AROUND A 3D
SHAPE WITH AN OPEN END. THE
SHAPE SHOULD BE WRAPPED IN CLING
FILM BEFORE THE STRING IS APPLIED
– THIS WILL MAKE IT EASY TO REMOVE
ONCE THE SCULPTURE IS DRY.

TO ADD COLOUR TO YOUR SCULPTURE,
ADD PAINT TO THE PVA GLUE BEFORE
YOU DIP IN THE STRING.

USE A BALLOON FOR A SPHERICAL
SHAPE AND POP IT WHEN THE STRING
IS DRY.

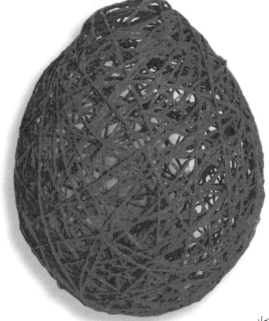

45

TAPE ART

TAPE ART DEVELOPED FROM URBAN
ART AS AN ALTERNATIVE TO THE
SPRAY CAN.

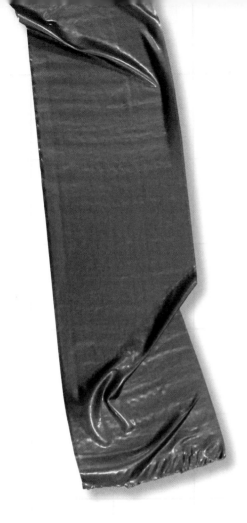

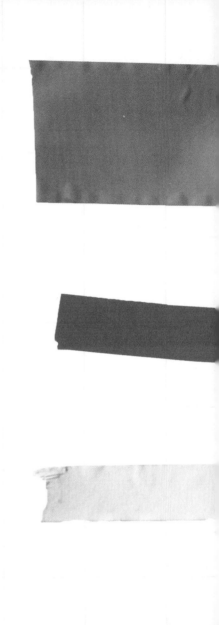

YOU CAN USE ANY VARIETY OF
ADHESIVE TAPE: MASKING TAPE,
PACKING TAPE, DUCT TAPE,
SELLOTAPE, GAFFER TAPE,
PARCEL TAPE, INSULATION TAPE...

PARCEL TAPE

DUCT TAPE

INSULATION TAPE

MASKING TAPE

GAFFER TAPE

GEOMETRICS

EXPLORE GEOMETRIC
SHAPES AND PATTERNS...

...AND APPLY TO VARIOUS
SURFACES — WOOD, STONE,
ALUMINIUM, GLASS.

Tumble
(gaffer tape on rendered wall)

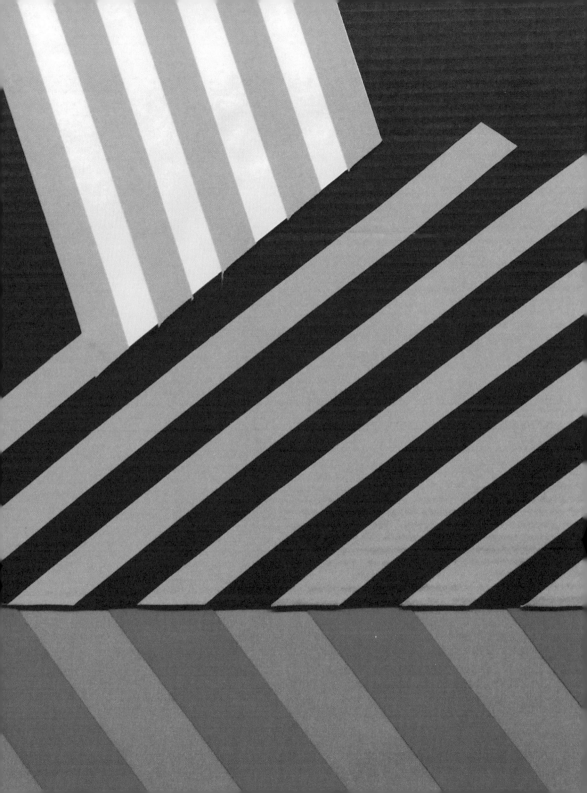

URBAN LINE

TAPE ARTISTS COVER THE STREETS –
WALLS, LAMPOSTS, PILLARS, RAILINGS,
DOORS, FENCES, ARCHWAYS...

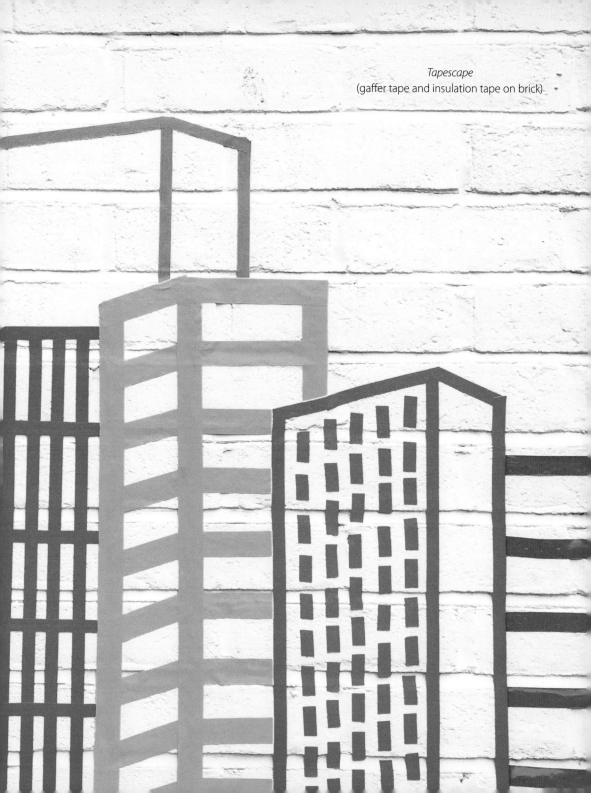

Tapescape
(gaffer tape and insulation tape on brick)

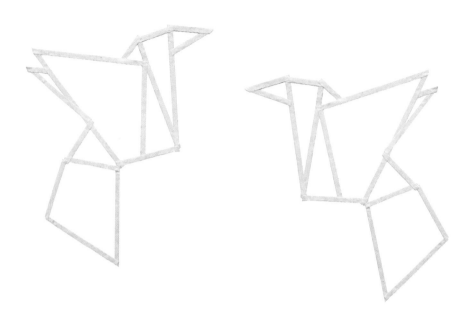

CREATE YOUR TAPE DESIGNS IN PUBLIC
SPACES, PHOTOGRAPH AND REMOVE.

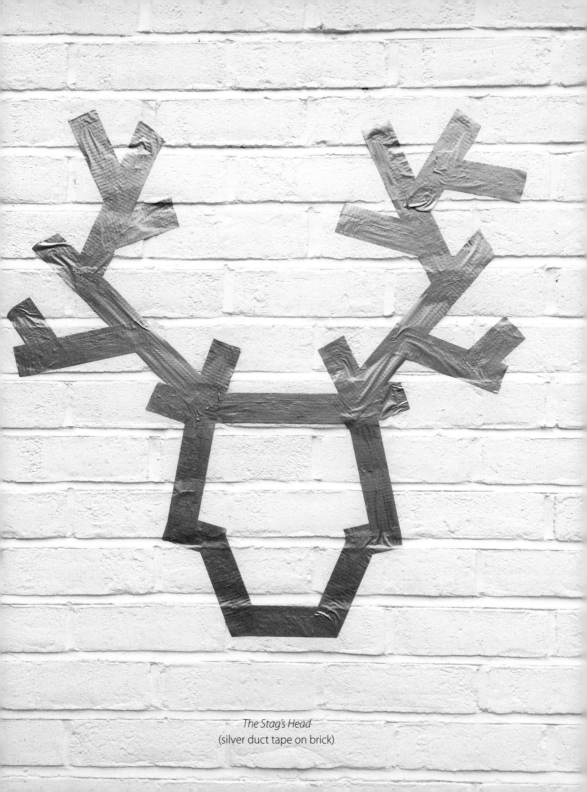

The Stag's Head
(silver duct tape on brick)

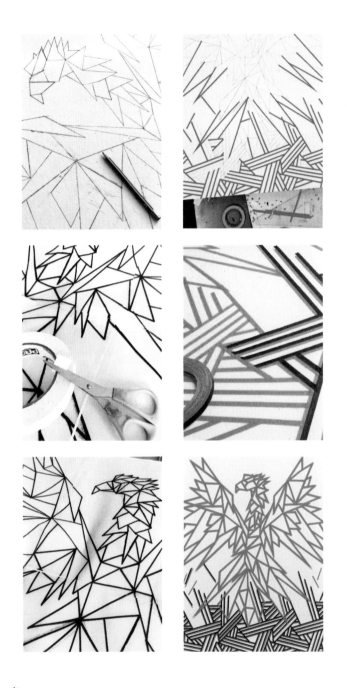

TAPE ART IS GENERALLY A SPONTANEOUS PROCESS, AS THE TAPE DESIGNS ARE APPLIED TO SURFACES, PHOTOGRAPHED AND REMOVED... BUT IT CAN ALSO BE CAREFULLY PLANNED IF YOU WISH TO PRODUCE A PERMANENT, MORE CONTROLLED ARTWORK.

Alfie McMeeking
Phoenix
(gaffer tape on industrial board)

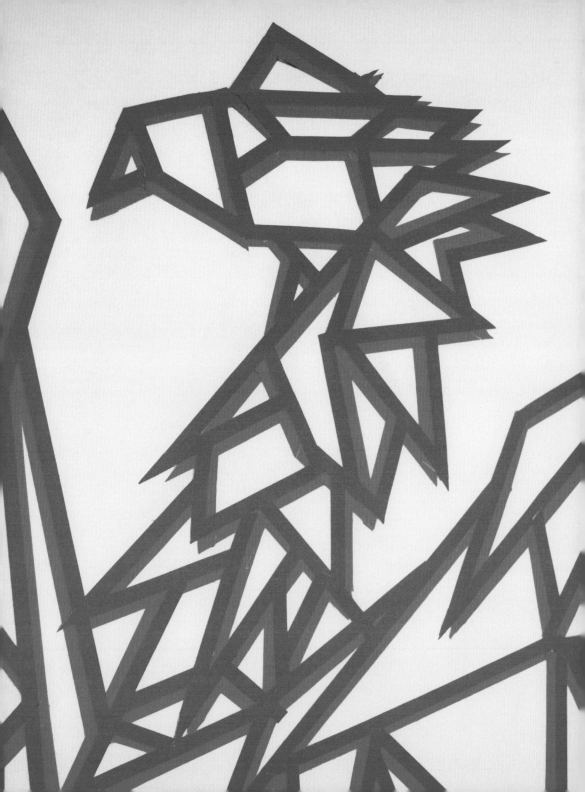

CONTRASTING TAPE COLOUR ADDS
DEPTH AND 3D PERSPECTIVE TO
GEOMETRIC SHAPES.

Above: **Archie Midgley** – *Impossible Triangle* (tape art)
Right: **Alfie McMeeking** – *Criss Cross* (tape art)

CREATE A SHAPE OR PATTERN WITH MASKING TAPE.

MASK AN AREA TO CREATE AN IMAGE OR PATTERN. ADD PAINT AND TEXTURE TO THE WHOLE SURFACE. WHEN DRY, REMOVE THE TAPE TO REVEAL THE FINAL ARTWORK.

Left: *Blocks*
(paint, ink, tape on watercolour paper)

ARTISTS WORTH EXPLORING:

CONTINUOUS LINE ARTISTS:
PABLO PICASSO (1881–1973)

WIRE ARTISTS
ALEXANDER CALDER (1898–1976)
DAVID OLIVEIRA (1980–)

TAPE ARTISTS
AAKASH NIHALAN (1986–)
MAX ZORN (1982–)
MARK KHAISMAN (1958–)

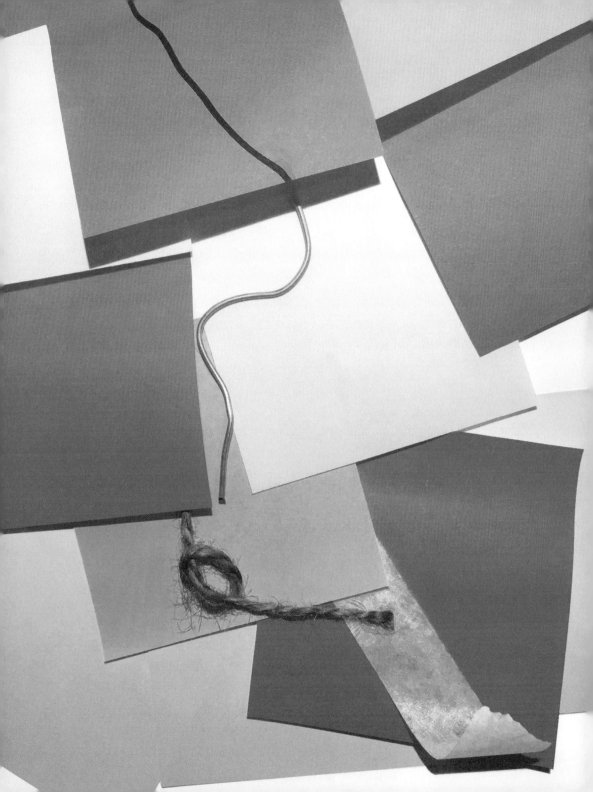

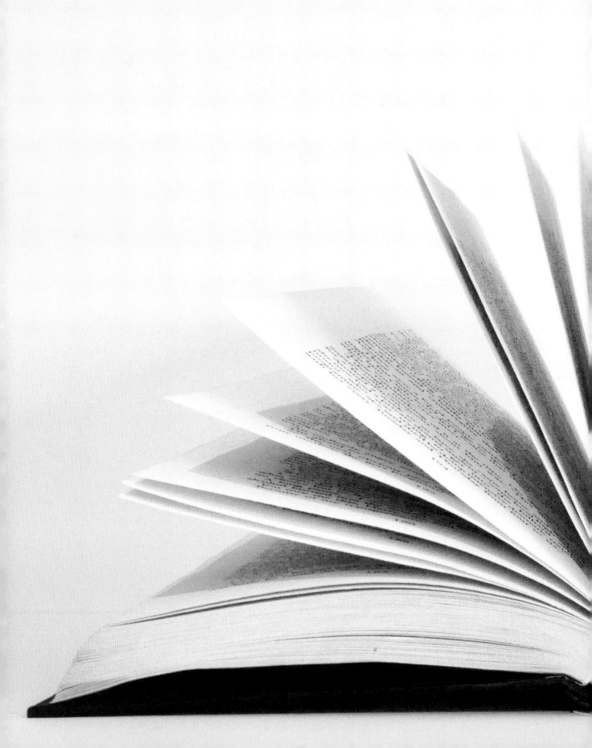

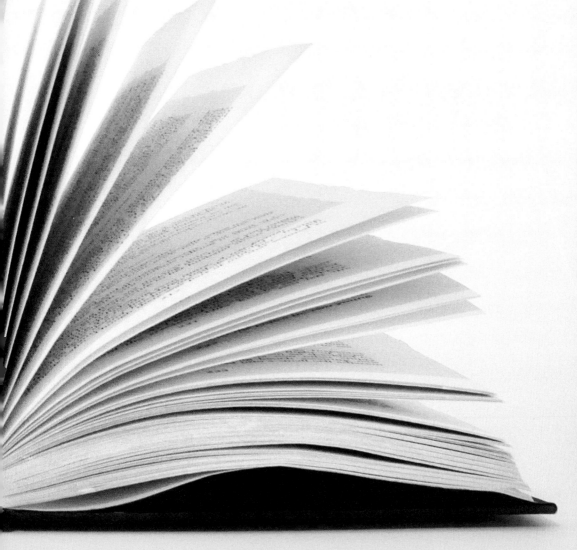

BOOK
RECREATING PAGES

EXPLORING
SCULPTURE

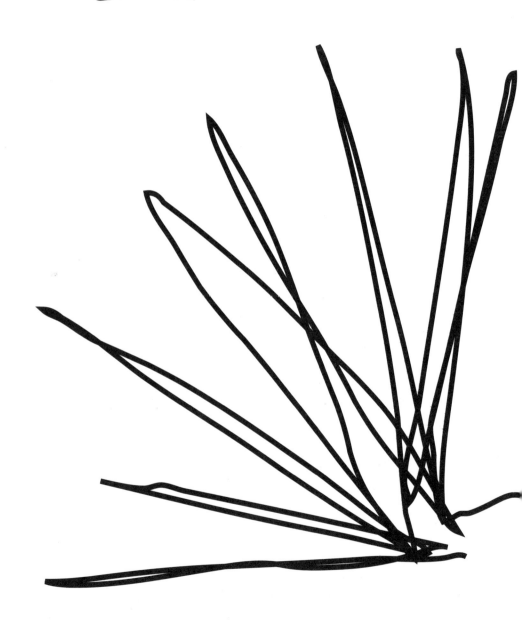

A BOOK GIVES YOU A FAMILIAR FORM TO PLAY WITH,
SO IT'S AN IDEAL WAY TO EXPLORE PAPER SCULPTURE;
TO REINVENT RATHER THAN SCULPT FROM SCRATCH.
TAKING A BOOK'S TITLE AND CONTENT AS YOUR STARTING
POINT, YOU CAN ILLUSTRATE ITS THEME AS ONE SIMPLE
SHAPE, OR CREATE MORE COMPLEX EXTENSIONS WITH
TORN PAGES, WIRE AND MORE.

YOU MIGHT GROW YOUR BOOK INTO A MINIATURE
LANDSCAPE, OR CREATE A SINGLE OBJECT THAT
REPRESENTS ITS CONTENT. YOU COULD BREAK THE SPINE,
MAKE A CAVITY IN A BLOCK OF PAGES, OR GO FOR SOME
INTRICATE PAPER-SCULPTING. HOWEVER YOU DO IT, YOUR
REINVENTED BOOK WILL TELL A VISUAL STORY, SHOWING
HOW YOU SEE ITS CONTENT.

SEARCH YOUR LOCAL CHARITY SHOP FOR AN OLD BOOK.
BE INSPIRED BY ITS SUBJECT, CONTENT OR COVER - FICTION
OR NON-FICTION, WHATEVER ATTRACTS YOU.

LOOK FOR COLOURS, PATTERNS OR PHOTOGRAPHS WITHIN
THE BOOK THAT APPEAL. THE COVER MIGHT STAND OUT,
OR SIMPLY THE TITLE.

MAYBE IT'S A BLOODTHIRSTY THRILLER... A SPOOKY TALE OF
HORROR... ARCHITECTURE OF THE ANCIENT WORLD... FLORA
AND FAUNA OF THE AMAZON RAINFOREST... FASHION
THROUGH THE AGES...

THIS IS YOUR STARTING POINT.

CHOOSE A BOOK...

A THRILLER?

ART DECO?

CALLIGRAPHY?

A BOOK ON BIRDS?

A TRAVEL GUIDE?

PATTERNS?

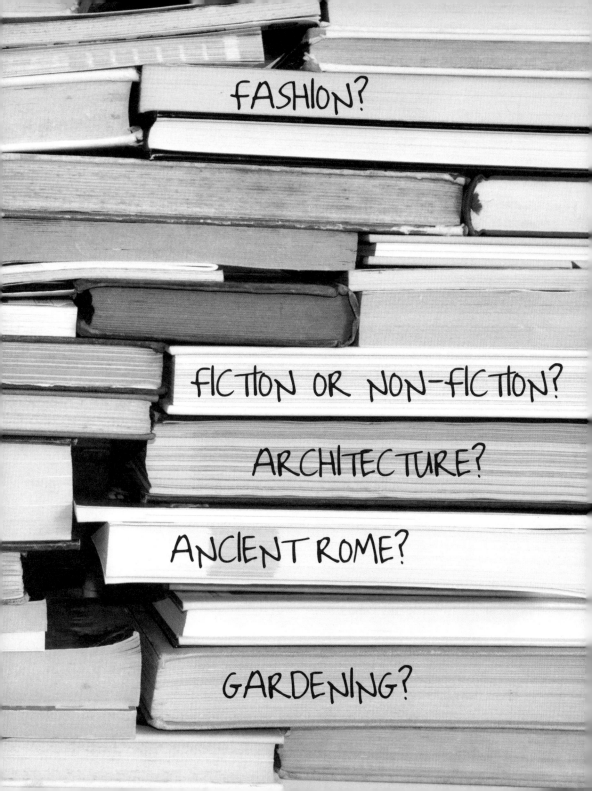

TELLING STORIES

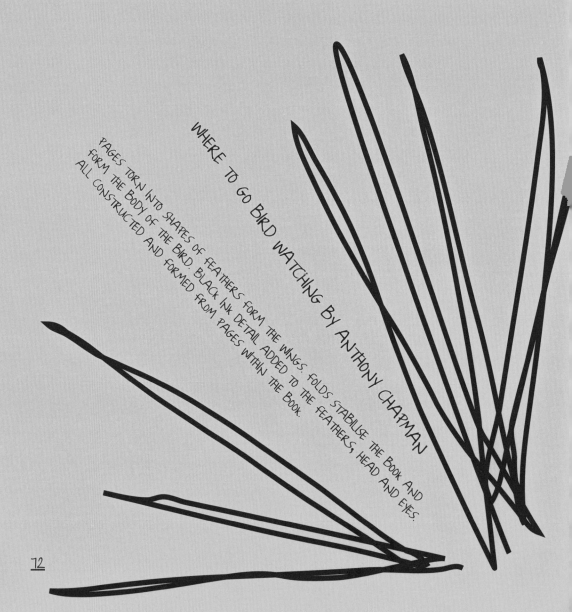

WHERE TO GO BIRD WATCHING BY ANTHONY CHAPMAN

PAGES TORN INTO SHAPES OF FEATHERS FORM THE WINGS. FOLDS STABILISE THE BOOK AND FORM THE BODY OF THE BIRD. BLACK INK DETAIL ADDED TO THE FEATHERS, HEAD AND EYES. ALL CONSTRUCTED AND FORMED FROM PAGES WITHIN THE BOOK.

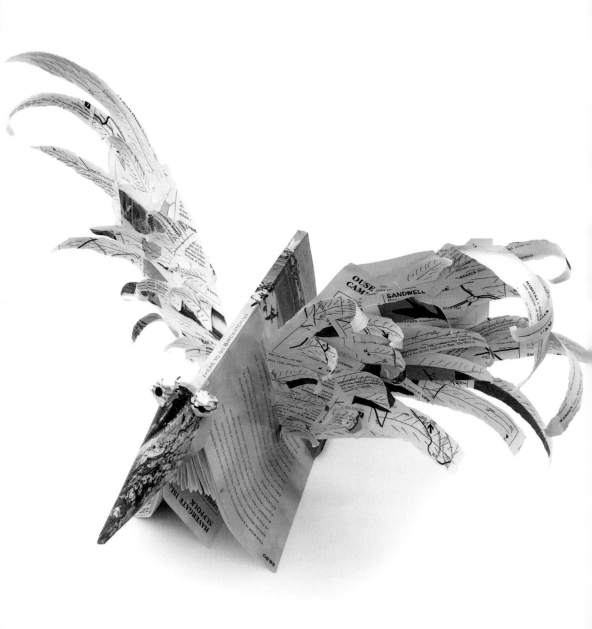

Sol Platt
Where to Go Bird Watching by Anthony Chapman
(collage, wire, papercuts)

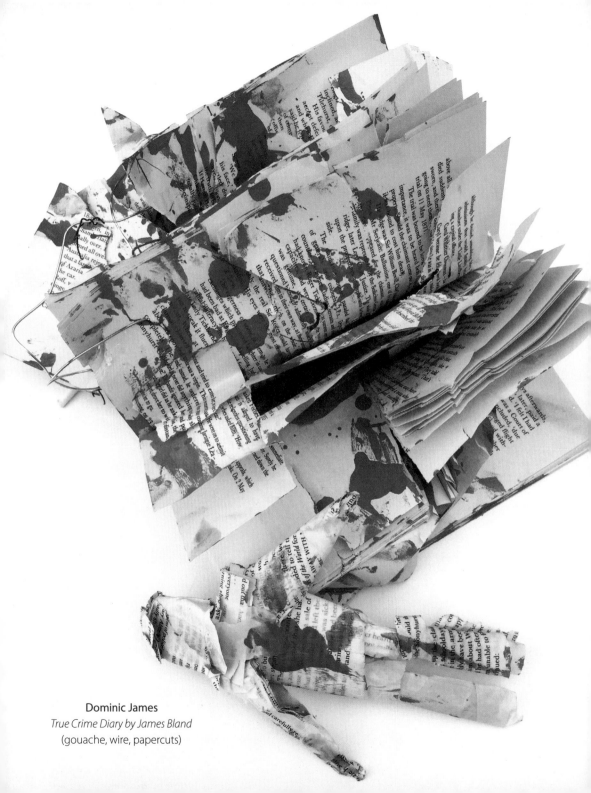

Dominic James
True Crime Diary by James Bland
(gouache, wire, papercuts)

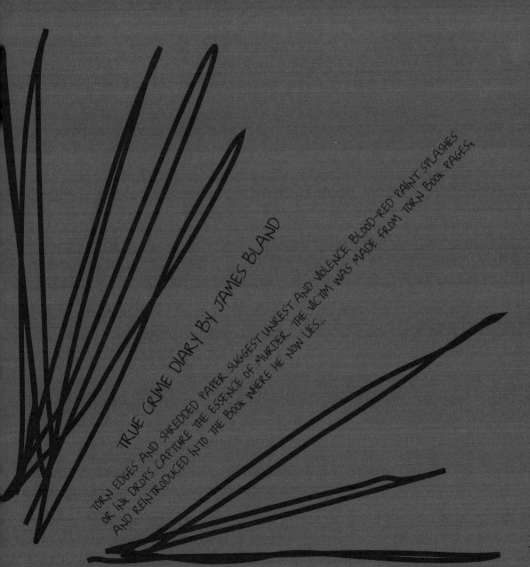

TRUE CRIME DIARY BY JAMES BLAND

TORN EDGES AND SHREDDED PAPER SUGGEST UNREST AND VIOLENCE. BLOOD-RED PAINT SPLASHES
OR INK DROPS CAPTURE THE ESSENCE OF MURDER. THE VICTIM WAS MADE FROM TORN BOOK PAGES,
AND REINTRODUCED INTO THE BOOK WHERE HE NOW LIES...

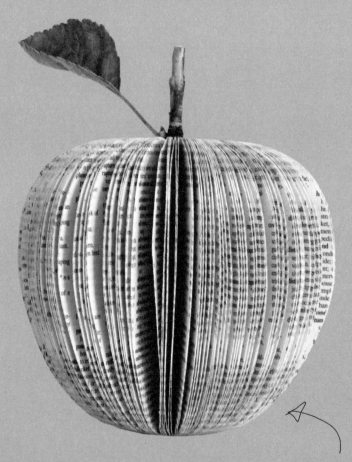

TO CREATE A SMOOTH FINISH, HOLD YOUR SHAPED PAGES FIRMLY TOGETHER AND GENTLY SAND THE EDGES.

David Midgley
The Fruit Tree Handbook by Ben Pike
(paper sculpting)

THE ROUGH-CUT PAGES
EVOKE THE DRAMATIC
GENRE OF THE BOOK.

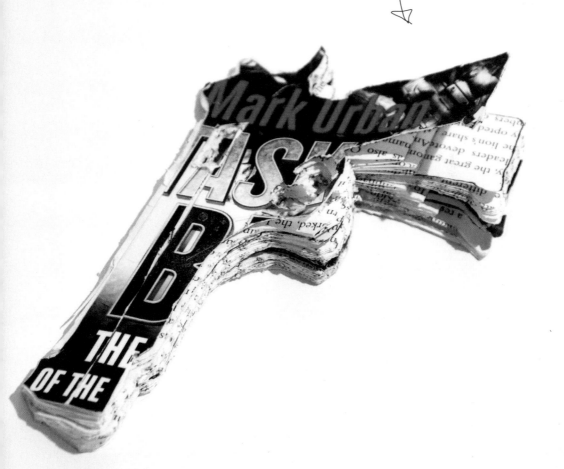

Dasiy Platt
Task Force Black by Mark Urban
(paper sculpting)

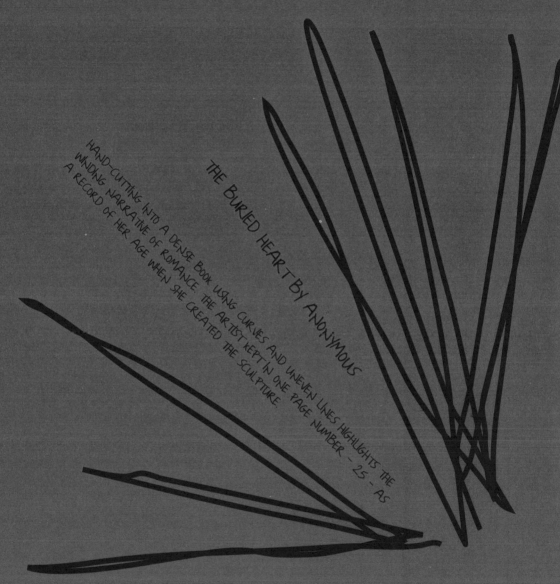

THE BURIED HEART BY ANONYMOUS

HAND-CUTTING INTO A DENSE BOOK USING CURVES AND UNEVEN LINES HIGHLIGHTS THE WINDING NARRATIVE OF ROMANCE. THE ARTIST KEPT IN ONE PAGE NUMBER - 25 - AS A RECORD OF HER AGE WHEN SHE CREATED THE SCULPTURE.

Gill Bennett
The Buried Heart by Anonymous
(paper sculpting)

way enough people for the hours of reading she p

un and stalked out of the room

a furtive man with a

tomorrow at seven? *Can't wait,*

conversation. Eats. We

her any more?

dan's a great name,' An

to overwhelming

Rose opened her

shuffle of slippers

put his arm

emphasise

across the

Miss Kirk – her

you have and new books and magic p

25

TECHNIQUES

BULKING UP

TO GIVE SUPPORT AND STABILITY TO THE SCULPTURE BASE, CURL THE PAGE EDGES TO THE CENTRE OF THE BOOK AND TUCK THEM IN. YOU COULD ADD CURLED PAPERS MADE FROM PHOTOCOPIES OF THE PAGES.

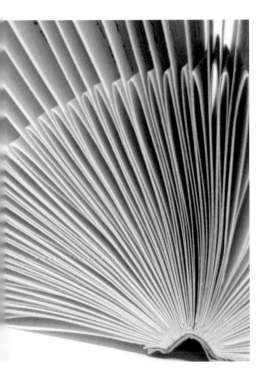

EXPERIMENT BY FOLDING BACK SELECTED PAGES IN BETWEEN EQUAL SECTIONS THROUGHOUT. YOU CAN VARY THIS DEPENDING ON THE THICKNESS OF THE BOOK AND WHAT YOU ARE TRYING TO ACHIEVE.

PAPER GLUE WILL HOLD THE PAGES SECURELY.

THIS IS A GOOD WAY TO ADD VOLUME TO A THIN BOOK WITH FEW PAGES.

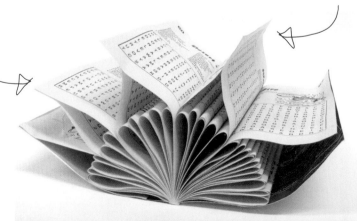

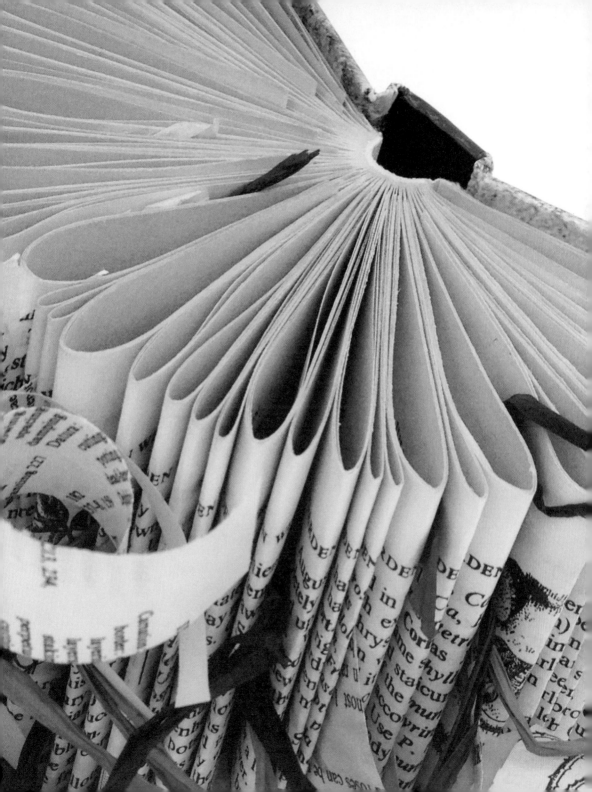

CREATING TEXTURE.

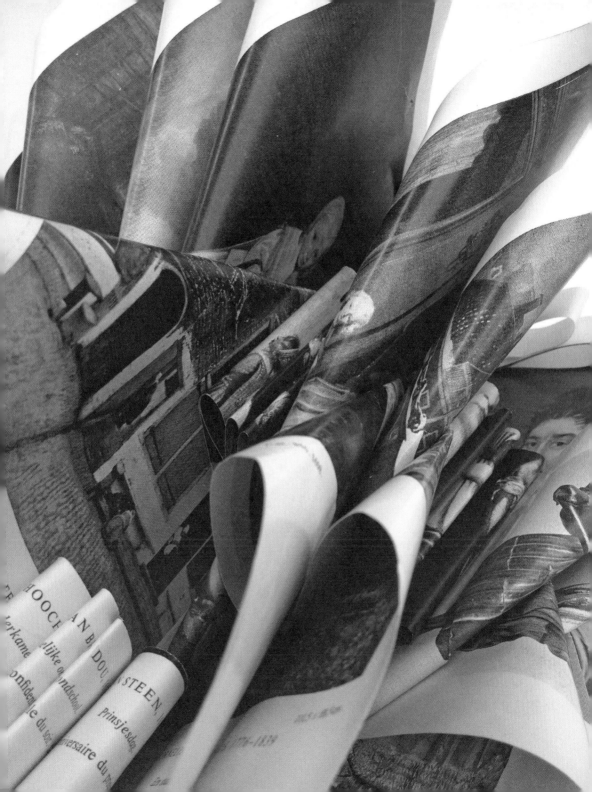

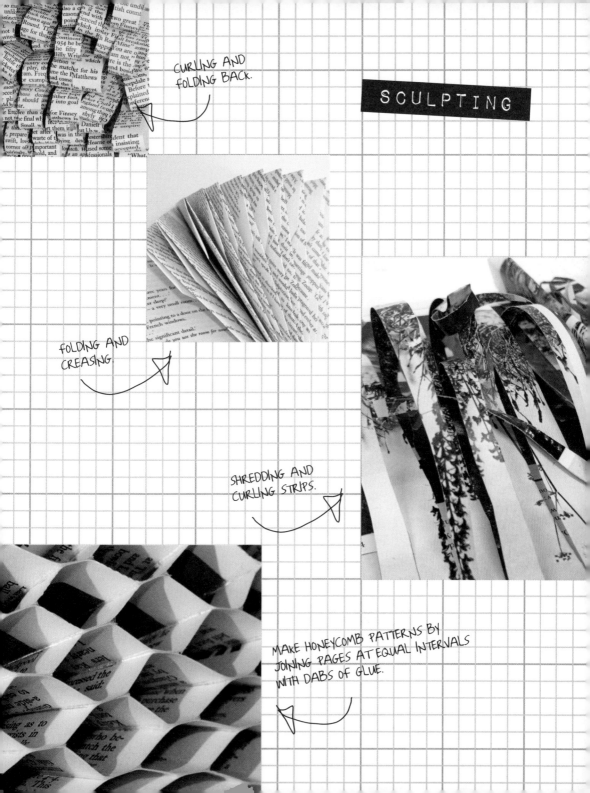

CURLING AND
FOLDING BACK.

SCULPTING

FOLDING AND
CREASING.

SHREDDING AND
CURLING STRIPS.

MAKE HONEYCOMB PATTERNS BY
JOINING PAGES AT EQUAL INTERVALS
WITH DABS OF GLUE.

TO ADD PATTERN AND TEXTURE, TEAR OUT A BOOK
PAGE OR CHOOSE AN ADDITIONAL PIECE OF PAPER.
CUT OUT A SIMPLE REPEAT SHAPE USING A CUTTING
MAT, OR PARTIALLY CUT SHAPES, THEN CAREFULLY
CURL THE CUT EDGES. PLACE IT OVER COLOURED PAPER
OR A COLOURFUL IMAGE AND REINTRODUCE INTO
YOUR SCULPTURE.

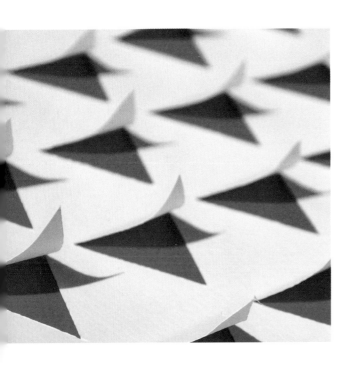

CUTTING AND CURLING TO REVEAL
A SOLID COLOUR BENEATH.

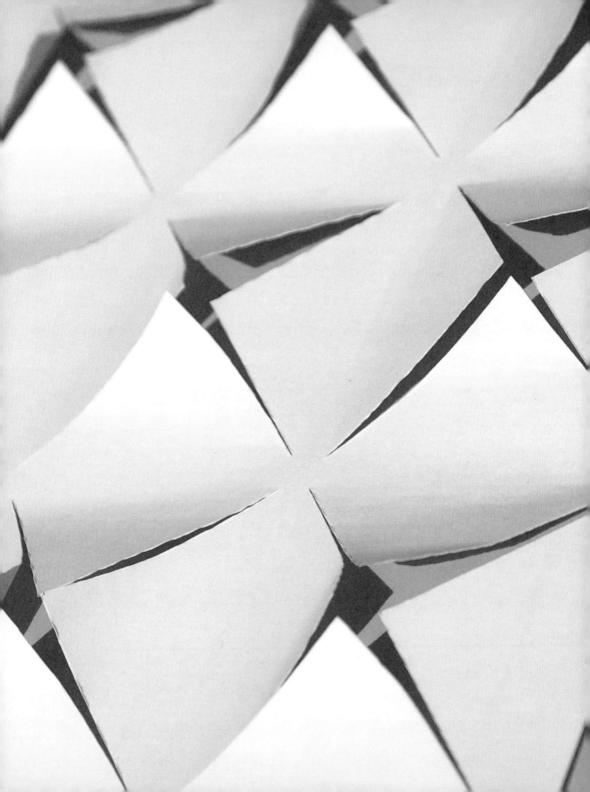

WEAVING

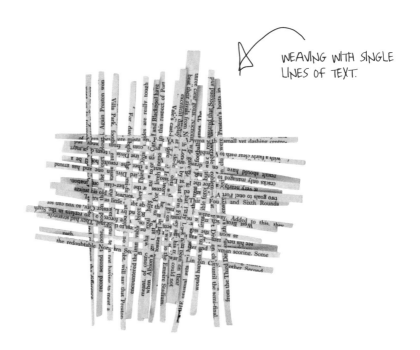

WEAVING WITH SINGLE LINES OF TEXT.

WEAVING ADDS A TACTILE ELEMENT — SLICED OR TORN PAGES FORM A JUMBLED TEXTURE OF WORDS OR IMAGES. YOU CAN WEAVE DIRECTLY INTO FIXED PAGES, OR REMOVE THEM FIRST, CUT, WEAVE, AND RETURN TO THE BOOK.

CUT AND TORN SLICES OF A SINGLE-PAGE IMAGE WOVEN BACK TOGETHER.

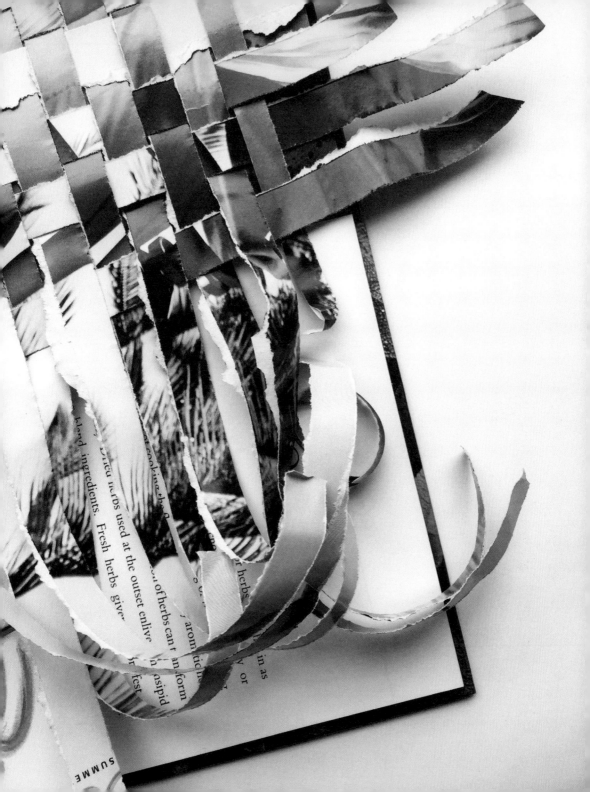

RAFFIA

ADD
WHATEVER YOU
LIKE TO YOUR
SCULPTURE.
ALONG WITH
STUFF LIKE
PAINT AND
NEWSPAPER,
TRY OUT
PLASTICS,
STRING,
FABRIC OR
FEATHERS.

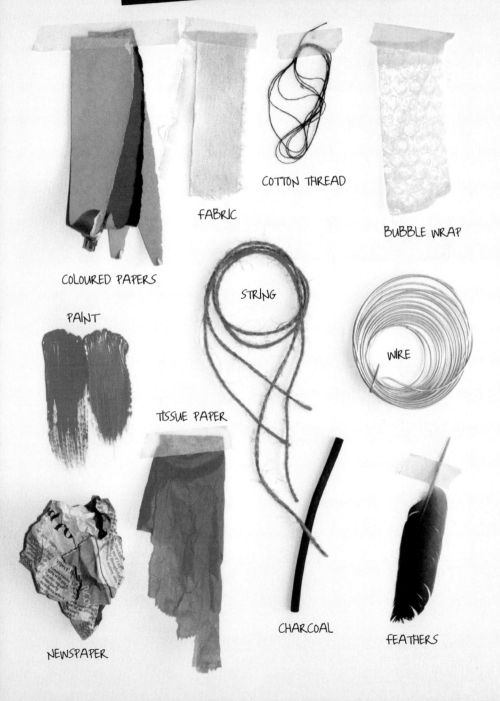

ADDING MATERIALS

COTTON THREAD

FABRIC

BUBBLE WRAP

COLOURED PAPERS

STRING

WIRE

PAINT

TISSUE PAPER

NEWSPAPER

CHARCOAL

FEATHERS

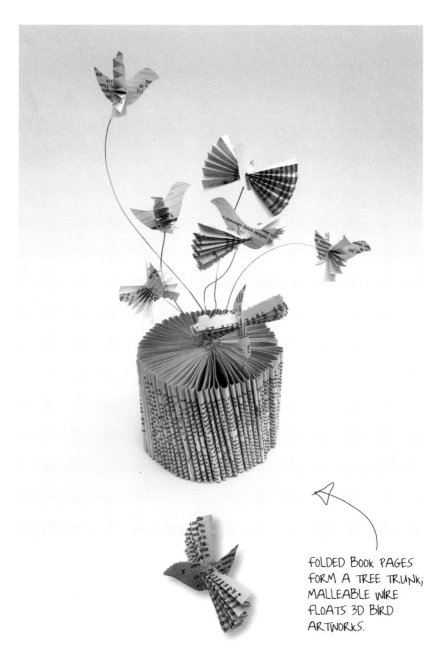

FOLDED BOOK PAGES
FORM A TREE TRUNK;
MALLEABLE WIRE
FLOATS 3D BIRD
ARTWORKS.

The Birds
(book sculpture with wire)

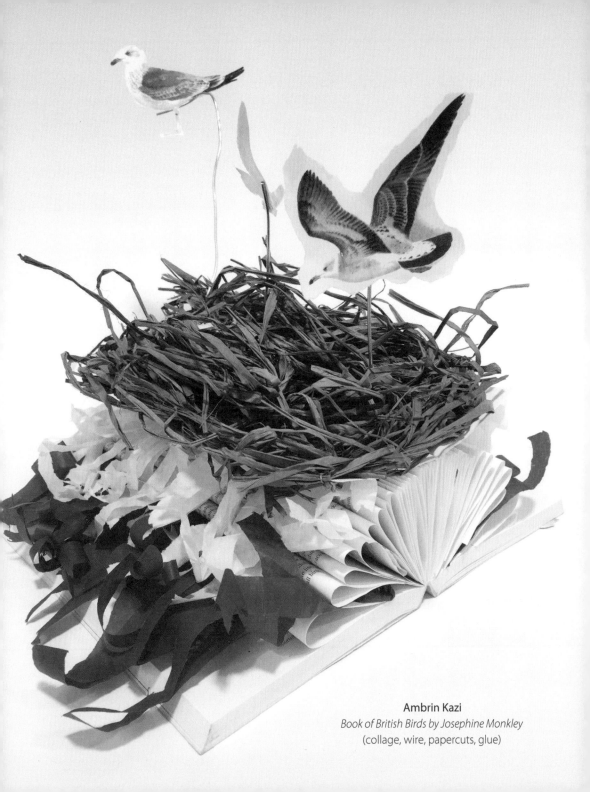

Ambrin Kazi
Book of British Birds by Josephine Monkley
(collage, wire, papercuts, glue)

ONE INTERPRETATION OF A PHRASE BOOK: WORDS,
TALKING, AN OPEN MOUTH — LIPS STICKY WITH GLUE.

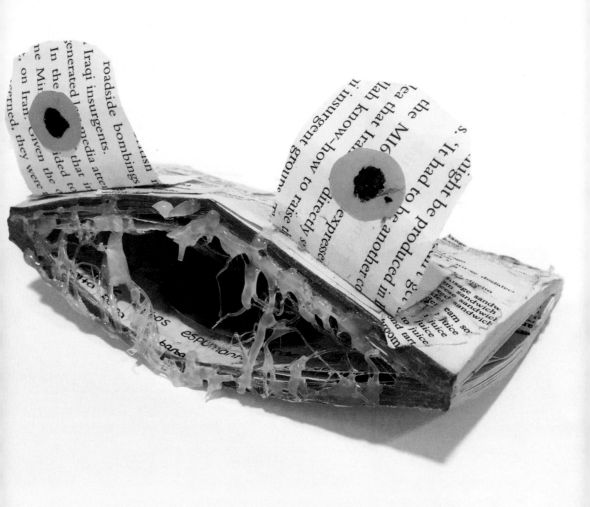

Sadie Jones
Portuguese Phrasebook
(glue, paint, paper, sculpting)

DISPLAY

ESTABLISH THE BEST POSITION FOR YOUR BOOK. LAY IT DOWN, STAND IT ON ITS SPINE, FOLD IT BACK ON ITSELF, VIEW IT FROM THE SIDE, VIEW IT FROM ABOVE.

CUT IT IN HALF, CUT IT UP INTO BITS... OR JOIN TOGETHER MORE THAN ONE BOOK.

LAY THE OPEN BOOK
FLAT, RESTING ON
THE OUTER COVER
SURFACE FOR
SUPPORT.

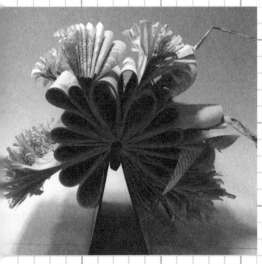

BEND THE COVER
BACKWARDS TO
MAKE A STAND.

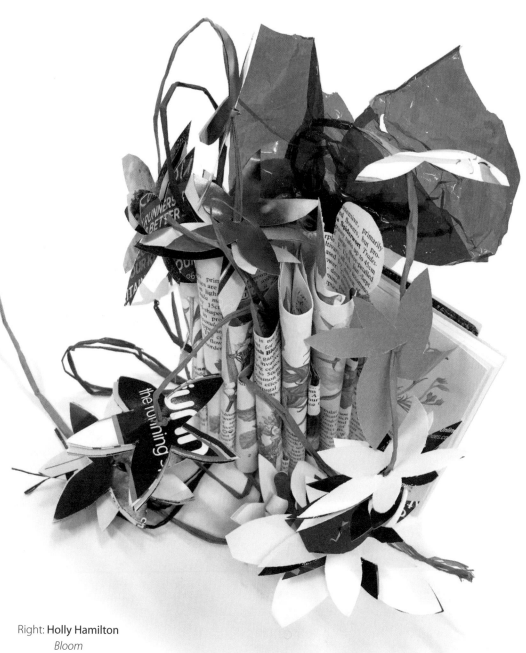

Right: **Holly Hamilton**
Bloom
(book sculpture with wire)

PLAY AROUND WITH
DISPLAY AND SELECT
YOUR FINAL POSITION.

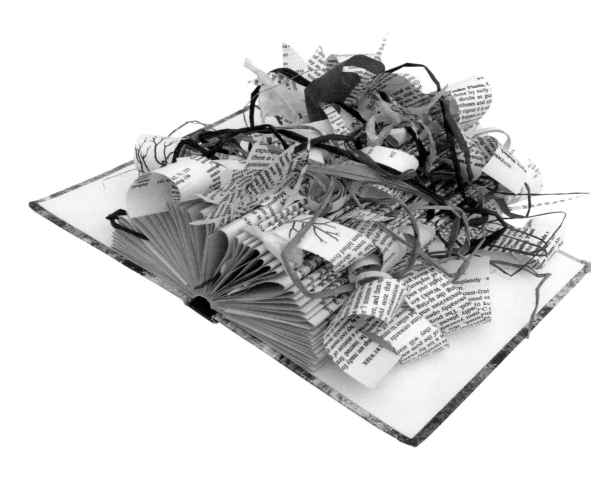

Anonymous
Word Forest
(glue, paint, paper, sculpting)

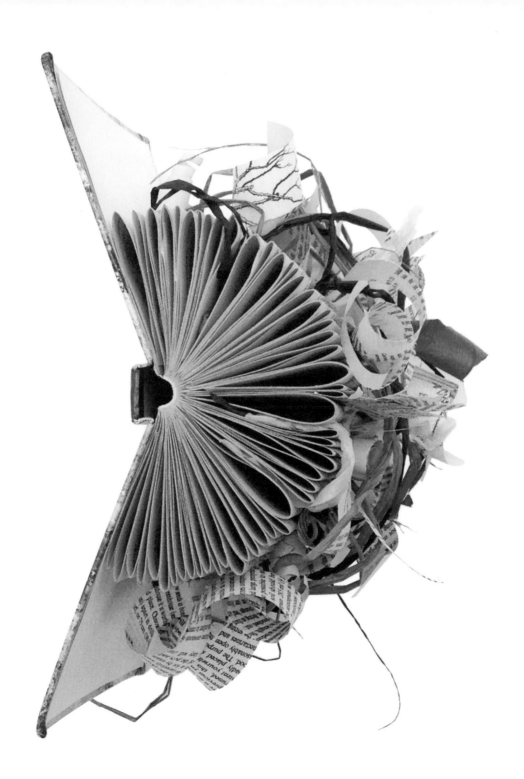

BOOKS WORTH EXPLORING:

500 PAPER OBJECTS BY GENE MCHUGH

ART MADE FROM BOOKS:
ALTERED, SCULPTED, CARVED,
TRANSFORMED BY ALYSON KUHN AND
LAURA HEUENGA

PLAYING WITH BOOKS:
UPCYCLING, DECONSTRUCTING AND
REIMAGINING THE BOOK BY JASON THOMPSON

THE REPURPOSED LIBRARY:
33 CRAFT PROJECTS THAT GIVE OLD BOOKS
NEW LIFE BY LISA OCCHIPINTI

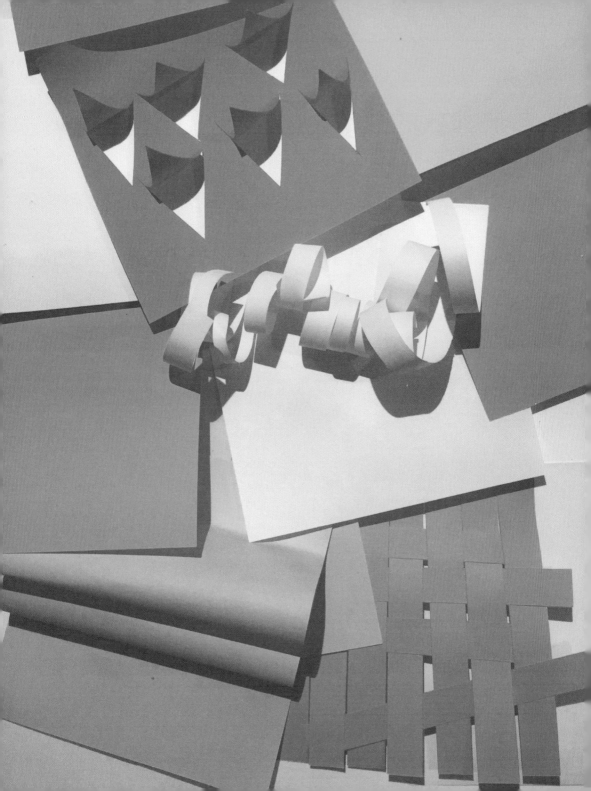

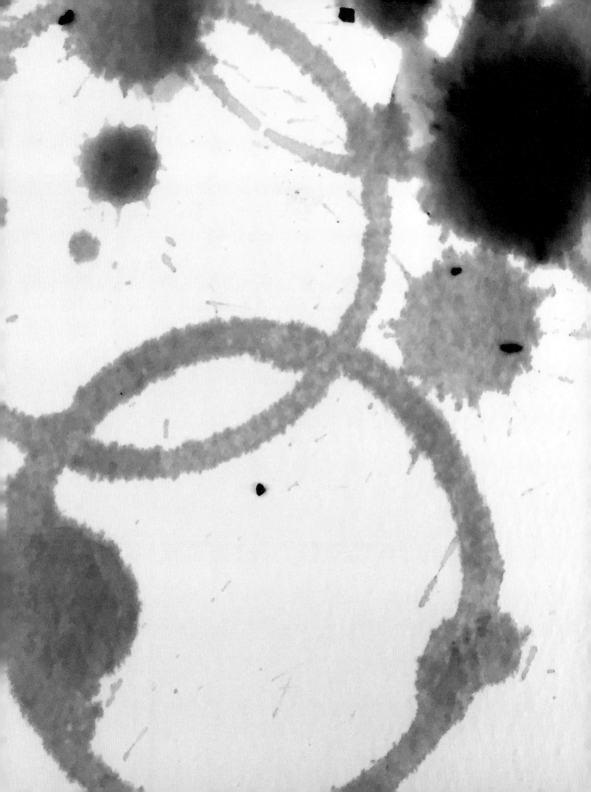

TRACES

OUTLINES & IMPRESSIONS

TRACES

TAKE THE WORD AS YOUR
STARTING POINT.

WHAT DOES IT MEAN TO YOU?

105

SILHOUETTE
VEINS
BARK
AGE
RINGS
TREES
LEAVES
HAIR
STRETCH
ELONGATE
FADE
DARK
DISTORT
LIGHT
MATURE
PERISH
BRITTLE
SKELETAL
DIRECTIO
STRING
CONTOURS
TRAIL
WRINKLE
CHANGE
FEATHERS
FLOWERS
ANIMALS
DECAY
TIME
MAPPING
WAL
PATH
EMPTY PLATE
NATURE
SHADOWS
AGE
PATTERN
TYRES
TEXTURES
MARKS
TRACES
TRACKS
TERRITORY
BRUSH
LINES
INK
SURFACES
IMPRESSION
UNMADE BED
SHOE SOLES
INDENT
WAX
REPEL
ABSORB
EMBOSS
CREASES
PILLOW
PERSONA
SHAPES
STAINS
DEBOSS
RIDGES
FACE
COFFEE CUP
DROPS
CAPTURE
FOLDS
FEATURES
HAN
COFFEE ART
WINE
SPLASH
MOMENT
FINGERPRINTS
SPIRA

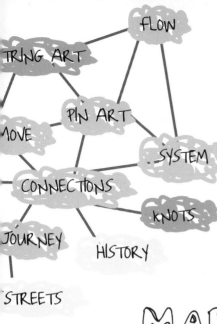

FLOW

TRING ART

PIN ART

MOVE

SYSTEM

CONNECTIONS

KNOTS

JOURNEY HISTORY

STREETS

EXTURES IMPRESSION

REPEAT

EPEAT — GEOMETRIC

ALEIDOSCOPE

MIRROR

TREAD

WEAR

RINTS — FADE

SAND

INES — SNOW

MAPPING IT OUT

A <u>WORD JOURNEY</u> OR MIND MAP
IS A GOOD WAY TO KICK OFF YOUR
THOUGHTS AND IDEAS - A BIT LIKE
WORD ASSOCIATION LETS YOUR IDEAS
FLOW. CHOOSE THE STRONGEST ROUTE
AND SEE WHERE IT TAKES YOU.

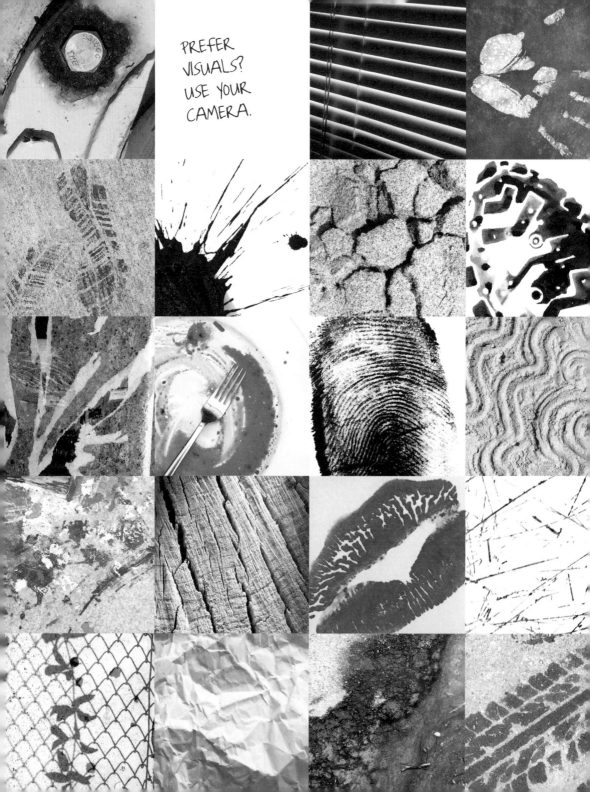

PREFER
VISUALS?
USE YOUR
CAMERA.

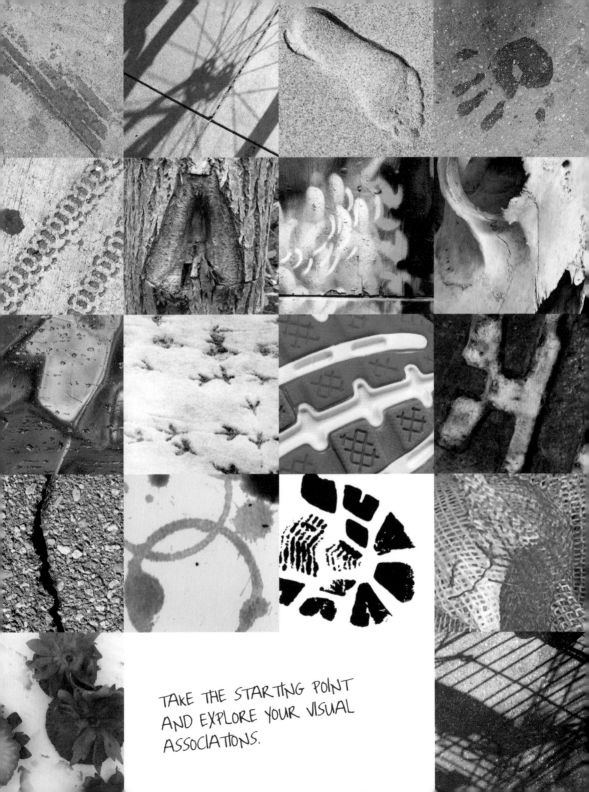

TAKE THE STARTING POINT
AND EXPLORE YOUR VISUAL
ASSOCIATIONS.

MADE FROM
A PINE CONE
ROLLED IN
BLACK INK ON
WATERCOLOUR
PAPER.

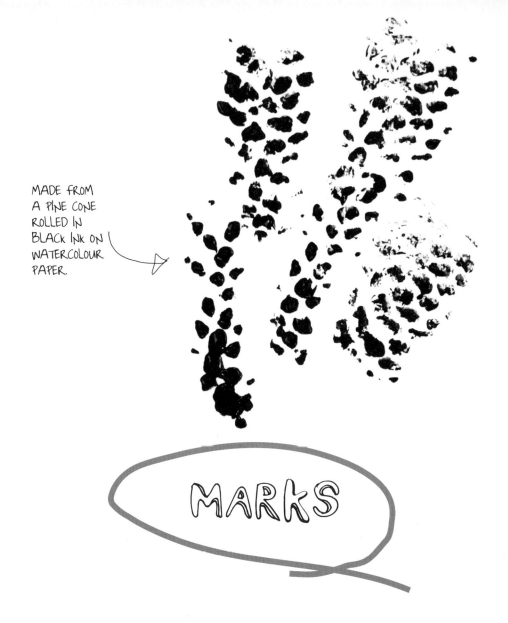

MARKS

START TO EXPERIMENT WITH MARK-MAKING.

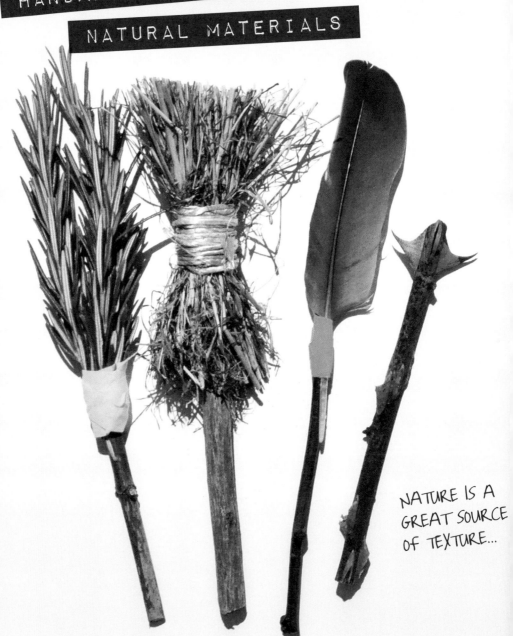

NATURE IS A
GREAT SOURCE
OF TEXTURE...

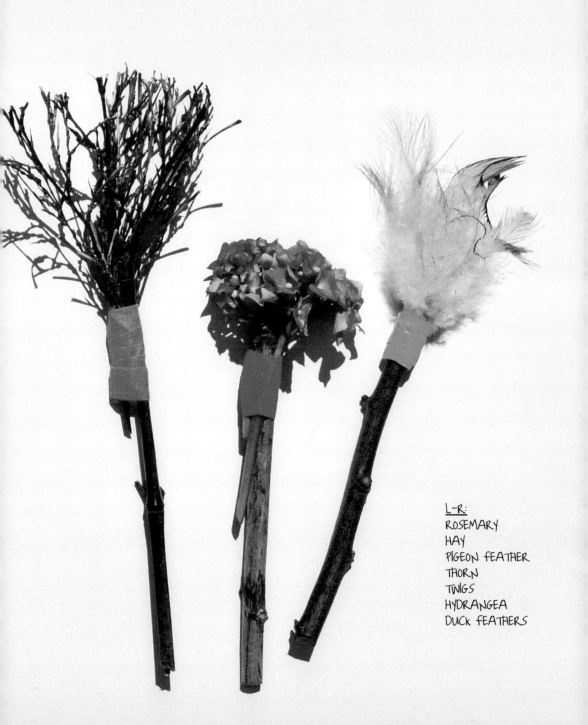

L-R:
ROSEMARY
HAY
PIGEON FEATHER
THORN
TWIGS
HYDRANGEA
DUCK FEATHERS

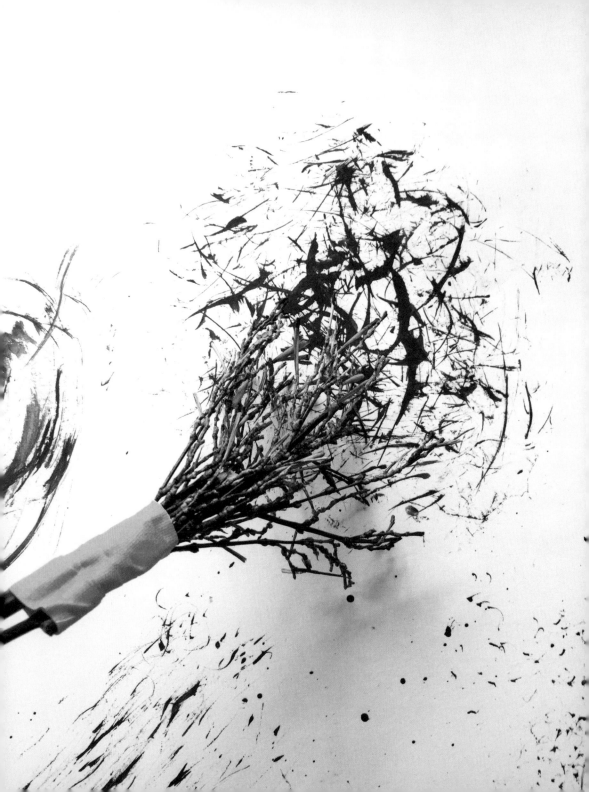

EXPERIMENT WITH THE TOOLS YOU CONSTRUCT
AND THE MARKS YOU MAKE....

TWIG BRUSH WITH
BLACK INK.

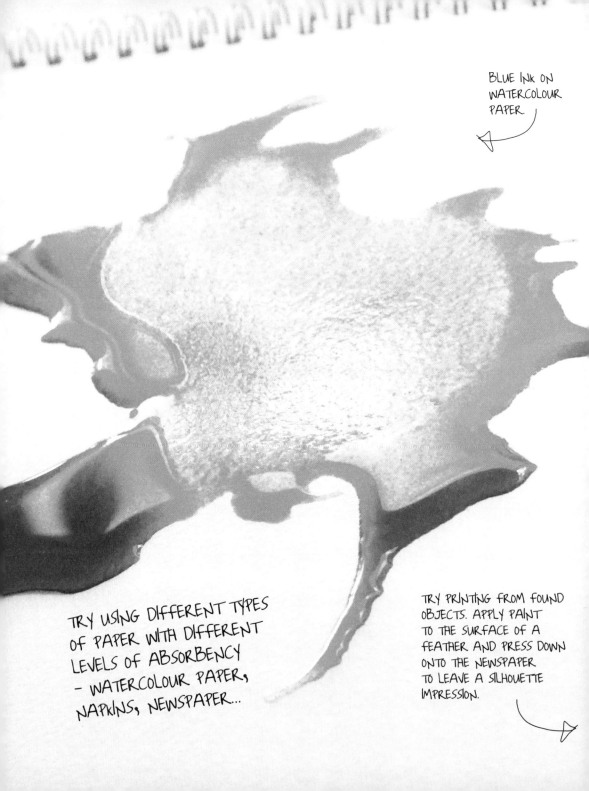

BLUE INK ON WATERCOLOUR PAPER.

TRY USING DIFFERENT TYPES OF PAPER WITH DIFFERENT LEVELS OF ABSORBENCY - WATERCOLOUR PAPER, NAPKINS, NEWSPAPER...

TRY PRINTING FROM FOUND OBJECTS. APPLY PAINT TO THE SURFACE OF A FEATHER AND PRESS DOWN ONTO THE NEWSPAPER TO LEAVE A SILHOUETTE IMPRESSION.

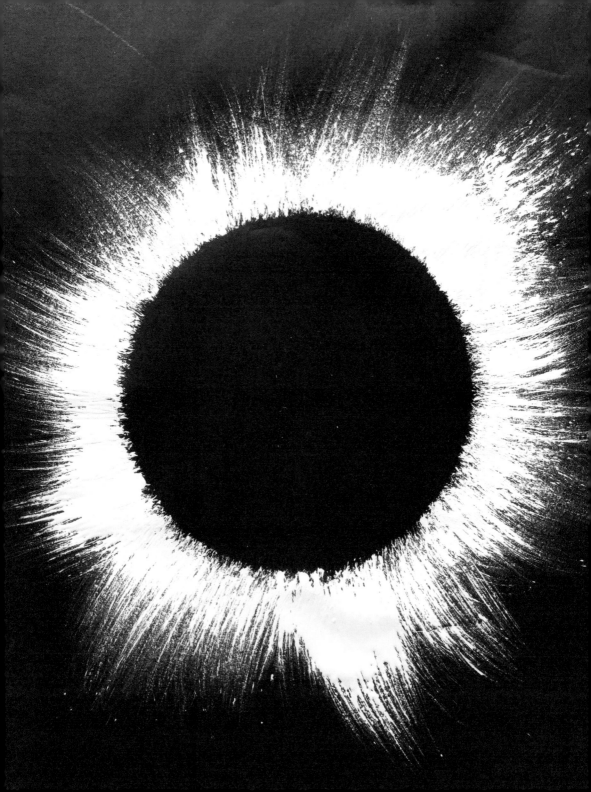

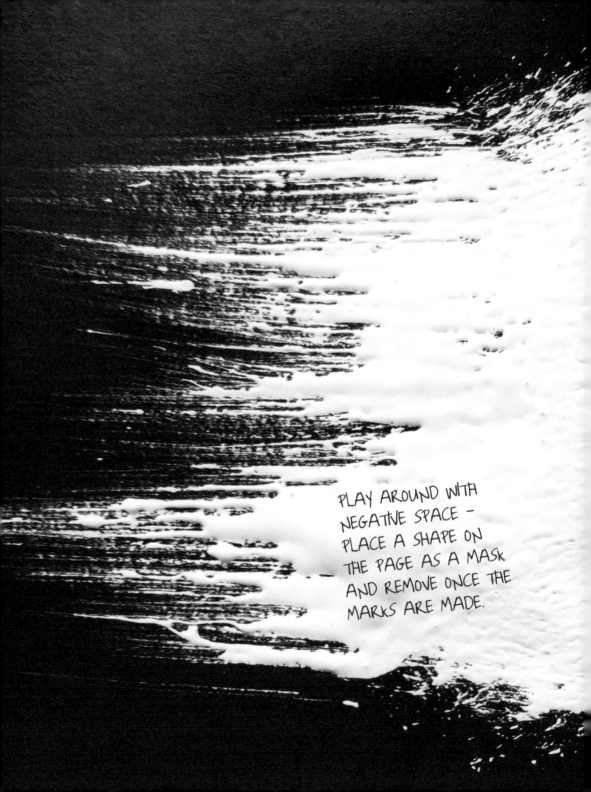

PLAY AROUND WITH
NEGATIVE SPACE -
PLACE A SHAPE ON
THE PAGE AS A MASK
AND REMOVE ONCE THE
MARKS ARE MADE.

HANDMADE BRUSHES 2: HOUSEHOLD MATERIALS

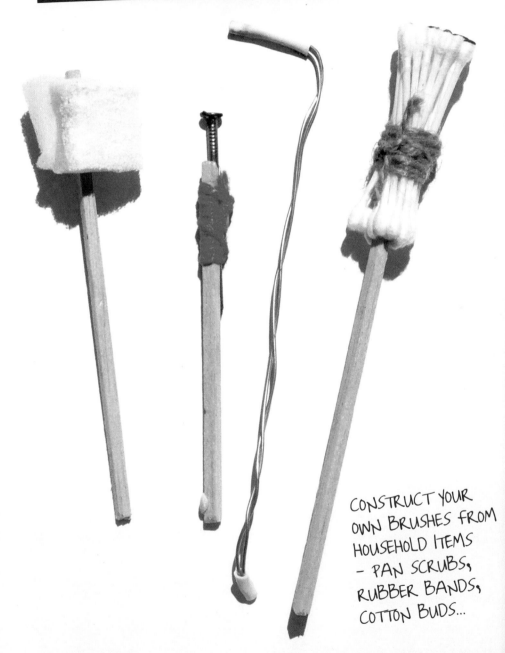

CONSTRUCT YOUR OWN BRUSHES FROM HOUSEHOLD ITEMS — PAN SCRUBS, RUBBER BANDS, COTTON BUDS...

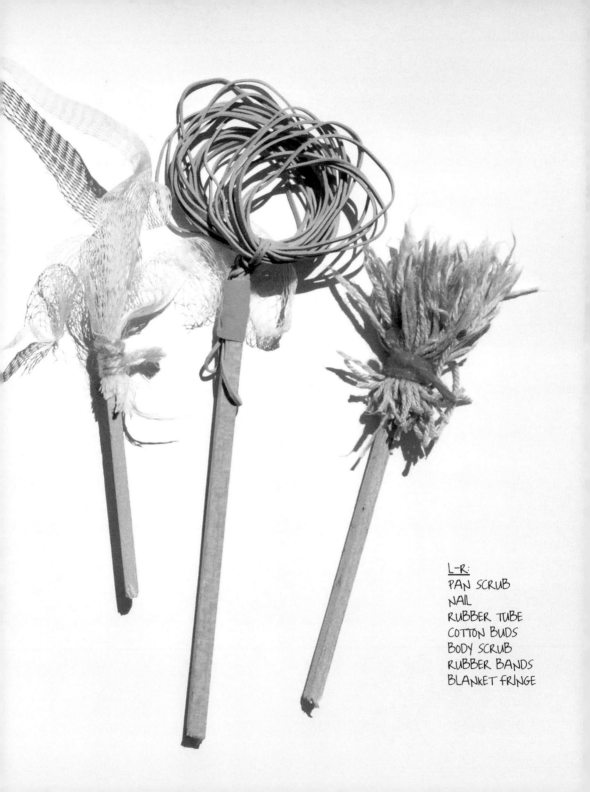

L-R:
PAN SCRUB
NAIL
RUBBER TUBE
COTTON BUDS
BODY SCRUB
RUBBER BANDS
BLANKET FRINGE

A LOADED PAINTBRUSH CAN BE
FORCEFULLY LANDED ON PAPER
TO CREATE DRAMATIC SPLASHES.
THE PAINT-TRACES CAPTURE
THE MOVEMENT.

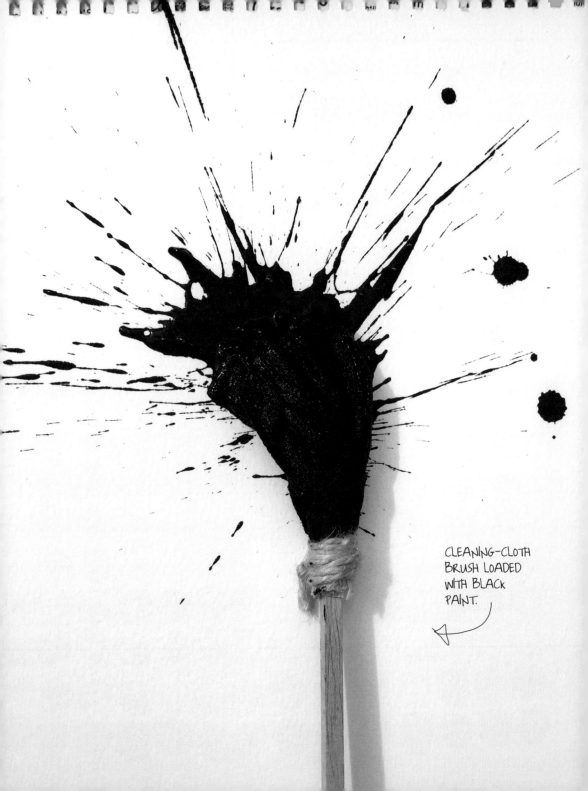

CLEANING-CLOTH
BRUSH LOADED
WITH BLACK
PAINT.

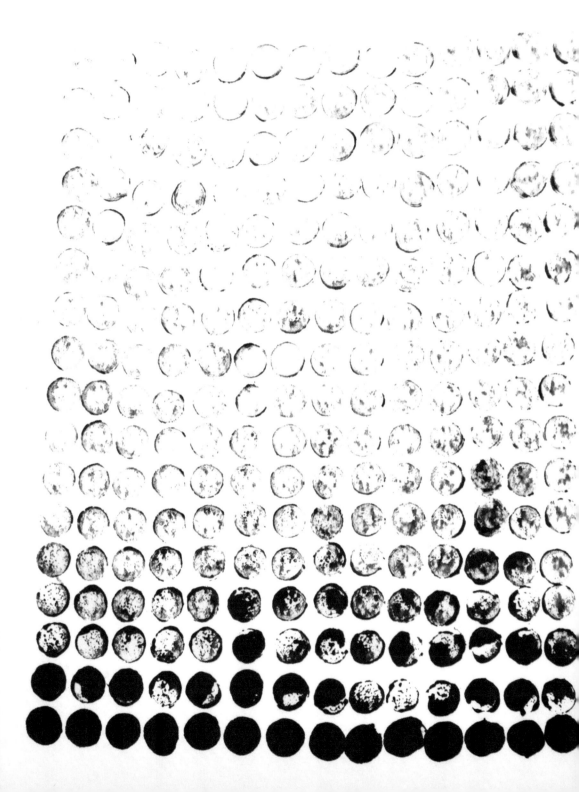

REPEATING MARKS — WITH EACH MARK MADE,
THE DENSITY OF THE COLOUR FADES. THIS KIND OF
REPLICATION CREATES A PATTERN THAT'S UNIQUE.

WORK IN VERTICAL
COLUMNS WITH ONE
DIP OF INK FOR
EACH COLUMN,
STARTING AT
THE BOTTOM AND
WORKING UPWARDS.

ARTWORK
CREATED BY
NAIL HEAD.

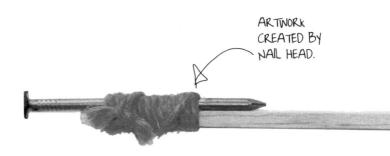

MASK IT OUT

PATTERNS WITHIN PATTERNS... USE MASKING TAPE TO
CREATE A GEOMETRIC GRID THEN LAY DOWN A PATTERN
MADE FROM A PAINT-LOADED COTTON BUD. REMOVE THE
TAPE TO REVEAL CLEAN-CUT LINES.

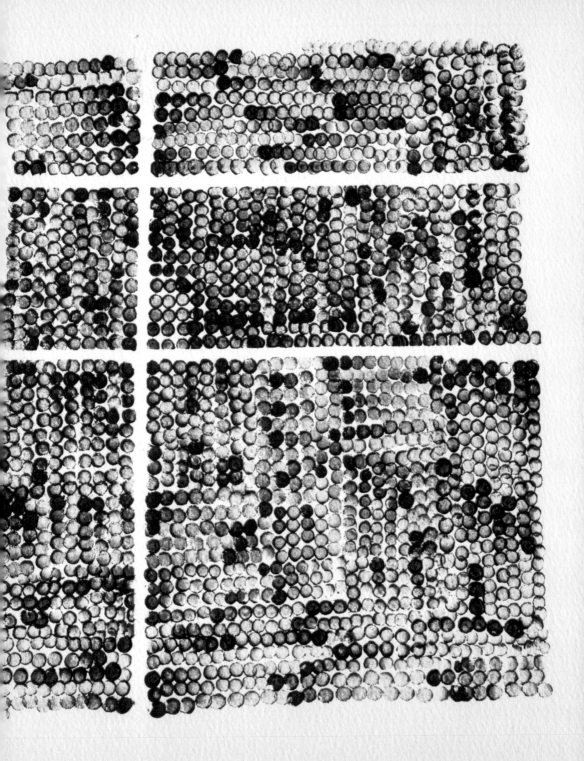

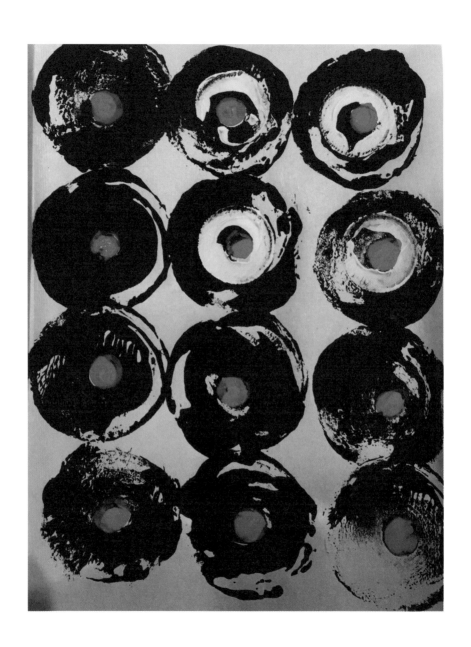

repeat, repeat
(plastic top, wooden bobbin)

PUT TOGETHER FOUND OBJECTS, SUCH AS A DISCARDED WOODEN BOBBIN AND THE PLASTIC TOP FROM A SKIN CREAM TUBE, AND CREATE INTERESTING POP-ART-STYLE REPEAT PATTERNS.

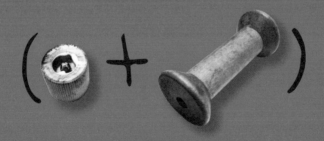

CREATE YOUR OWN PRINTING BLOCKS BY WRAPPING WOOL OR STRING AROUND WOOD PIECES. THE PATTERNS CAN BE UNIFORM OR OVERLAP RANDOMLY.

ADD CARDBOARD SHAPES TO THE BLOCKS TO CREATE MORE COMPLEX PATTERNS AND TEXTURES, OR JUST KEEP IT SIMPLE...

...PRINTING ONTO
WATERCOLOUR PAPER WITH INk...

...INTRODUCE DIFFERENT COLOURS
AND TRY NEW SURFACES.

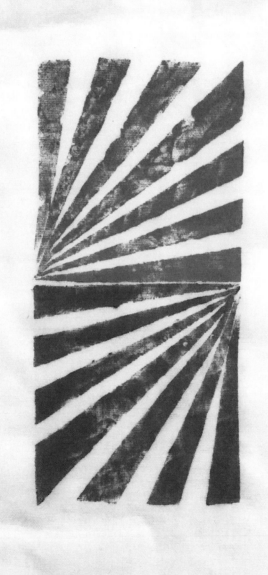

WRAP STRING AROUND OPEN PAGES OF A SKETCHBOOK, SECURING WITH MASKING TAPE AT THE BACK. VARY THE WIDTH OF THE LINES. WITH WATERED-DOWN PAINT AND A WIDE BRUSH, DRAG ACROSS THE PAGES ALLOWING PAINT TO CATCH ON THE STRINGS WITH EACH STROKE. WORK QUICKLY AND PHOTOGRAPH WHEN YOU'RE DONE.

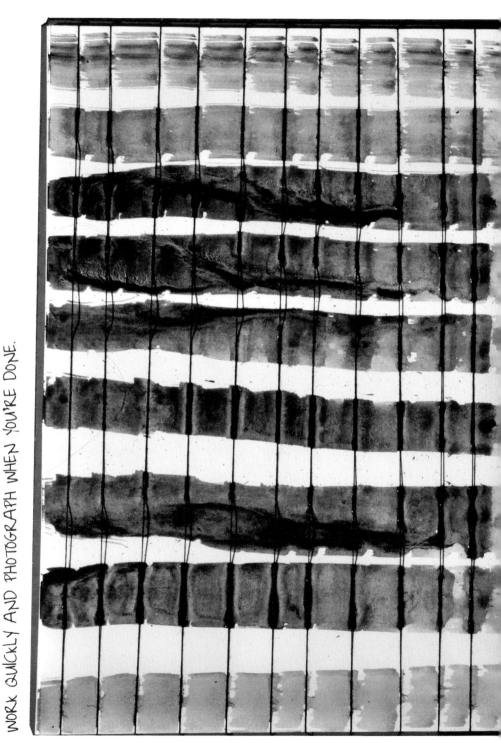

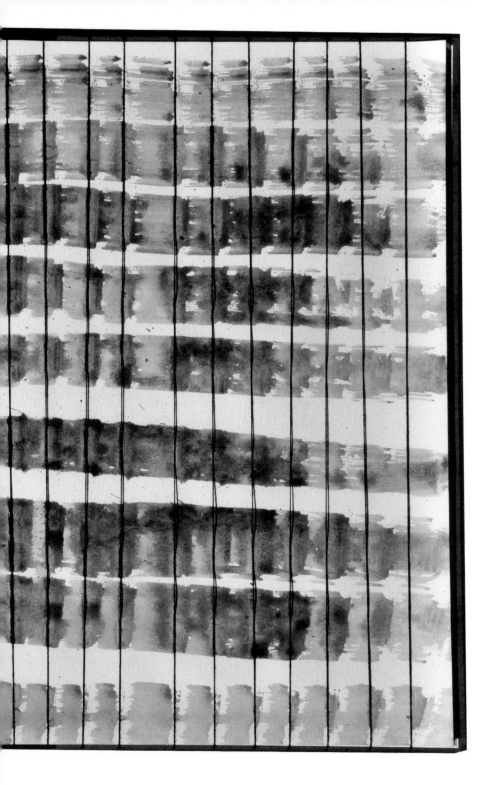

135

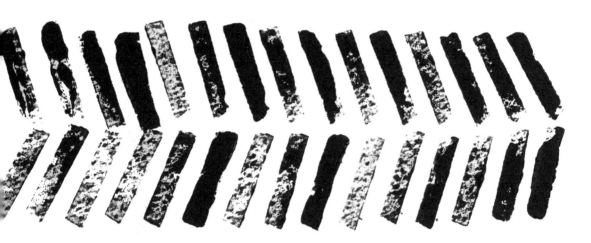

LOOK TO MAN-MADE TRACES FOR INSPIRATION: TRAINER TRACKS, A HANDPRINT, SPILLED LIQUID... AND EVOLVE SOME EXTRAORDINARY PATTERNS.

TRACKS

APPLY CHARCOAL, WATER-BASED INk OR PAINT TO THE SOLES OF YOUR OLD SPORTS SHOES... PRESS ONTO PAPER OR ANY SURFACE YOU LIKE.

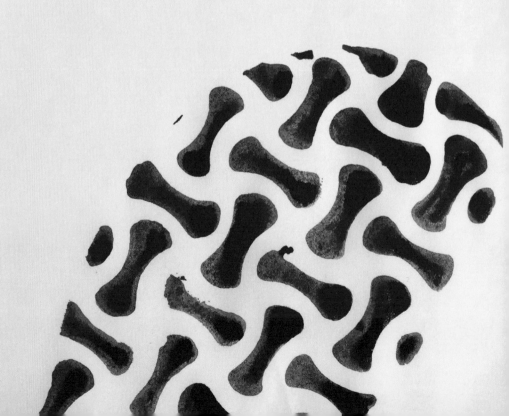

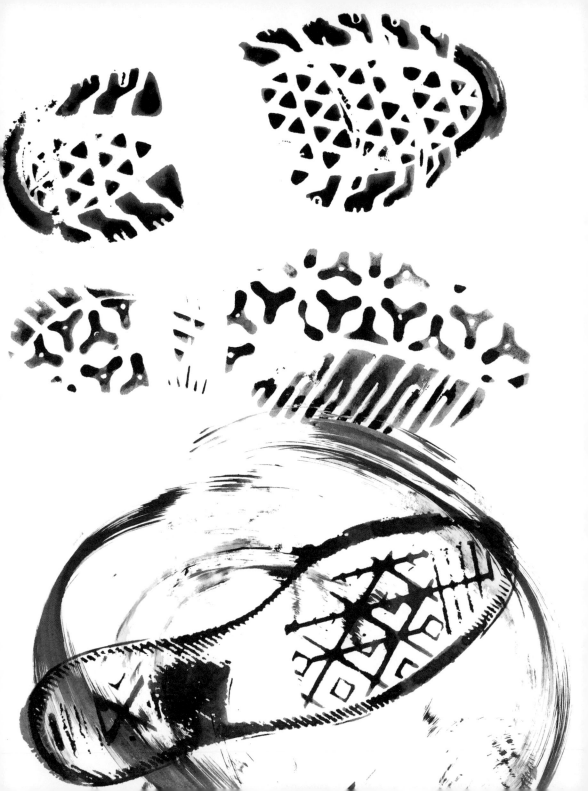

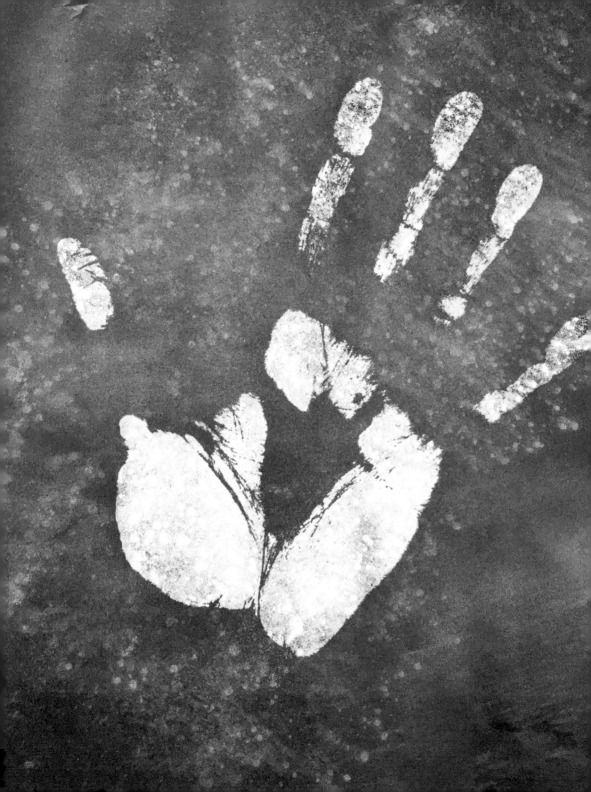

OIL + TALC

EXPERIMENT WITH IMPRESSIONS OR TRACES FROM THE BODY.

COVER YOUR PALMS WITH A THIN LAYER OF BODY OIL, DUST WITH TALC, PRESS THE PALM OF YOUR HAND ONTO DARK-COLOURED PAPER – IT LEAVES A DELICATE IMPRINT ON THE PAGE. BLOW AWAY EXCESS TALC. PHOTOGRAPH IT.

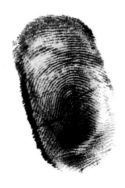

Left: *hand*
(oil, talc, paper)

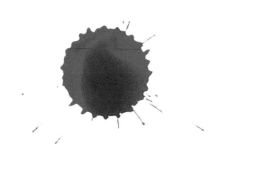

PAINT

GET MESSY. PAINT YOUR SKIN WITH WATER-BASED PAINT AND PRESS AGAINST A PIECE OF PAPER TO LEAVE AN IMPRINT.

FOCUS ON CREATING DIFFERENT SHAPES WITH PARTS OF YOUR BODY AND PUT THEM TOGETHER IN PATTERNS – CAPTURE WITH A CAMERA.

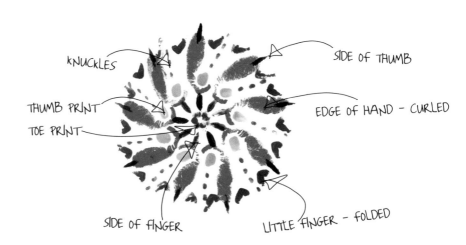

KNUCKLES

SIDE OF THUMB

THUMB PRINT

TOE PRINT

EDGE OF HAND – CURLED

SIDE OF FINGER

LITTLE FINGER – FOLDED

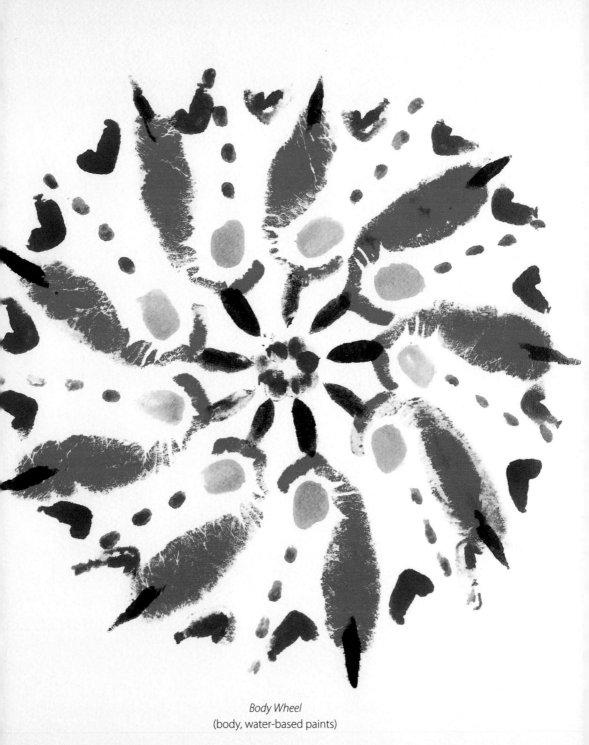

Body Wheel
(body, water-based paints)

COLLECT
AND CROP

PUT TOGETHER A PERSONAL PALETTE OF TEXTURE
AND PATTERN BY CROPPING YOUR ARTWORKS.

L-R
BALSA WOOD STICKS
NAIL
TWIGS
PAINT
SHOE PRINT

L-R
COTTON BUDS
WOOL
PEN TOP
SOLE
PAINT-LOADED BRUSH

L-R
STRAW&
TORN PAPER,
CORRECTION FLUID
SOLE
CARD BOBBIN

L-R
CARD DISC MASK
PLASTIC BOTTLE LID
THORN
MATCHSTICKS
PINE CONE

L-R
POLYSTYRENE PACKING
RUBBER TUBE
PAINT SWIRL
HAIR
CROSS-HATCHING

L-R
ROSEMARY
CUT PAPER STENCIL
EMBOSSED STRING
HYDRANGEA BRUSH
CORRECTION FLUID

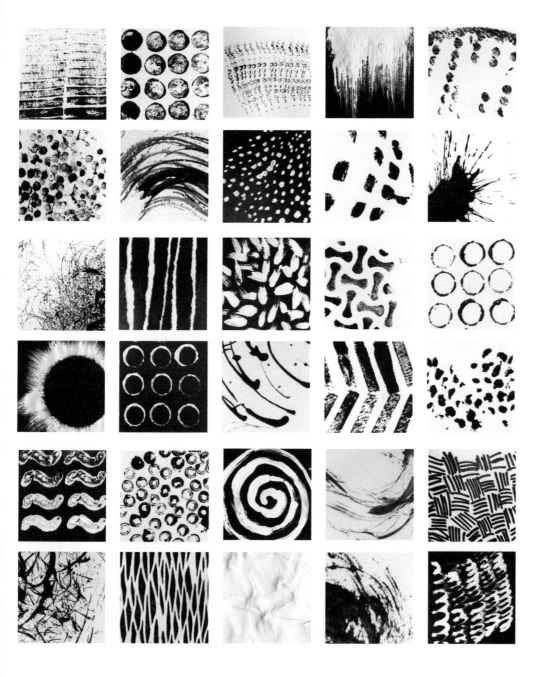

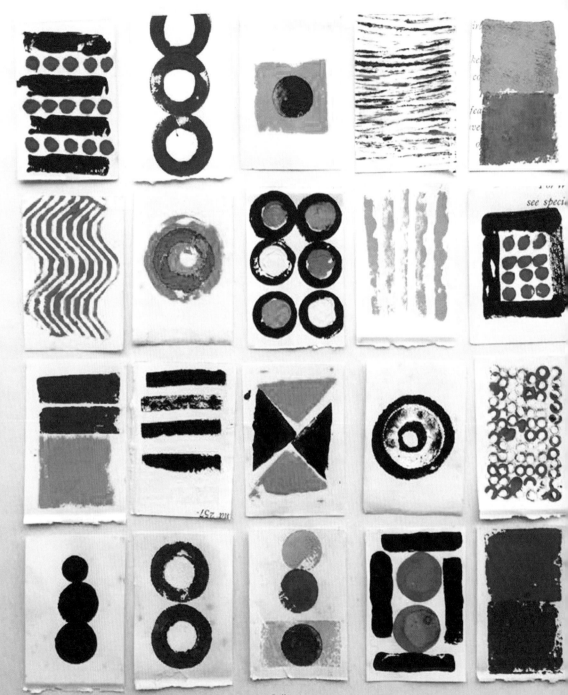

Collection
(paint, old book pages, various tools)

LET THE SHAPES, TEXTURES AND COLOURS YOU'VE
DISCOVERED WORK TOGETHER TO CREATE A COMPLETE
PIECE. DISPLAY SMALL ON A UNIFORM GRID.

MAINTAIN A STRONG MIX OF SIZE AND PROPORTION,
COMBINING DETAILS WITH BOLD PATTERNS.

SMALL PIECES OF PAPER CUT FROM AN OLD BOOK PROVIDE
AN INTERESTING TEXTURAL BASE FOR YOUR PATTERNS.
YOU CAN MOVE THE PATTERNS AROUND, CHANGING THE
ORDER UNTIL YOU GET A SATISFACTORY ARRANGEMENT.

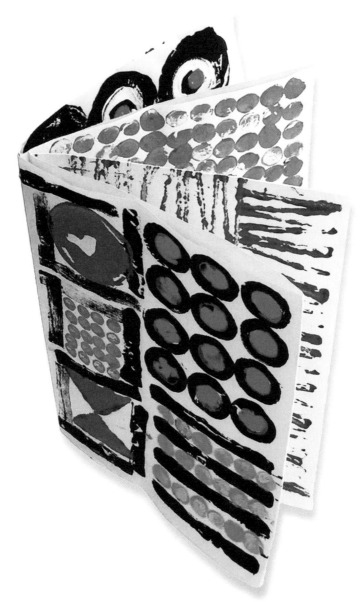

CREATE A PATTERN BOOK WITH THE MARKS YOU HAVE
MADE. NO GLUE REQUIRED... JUST FOLD AND CREASE.

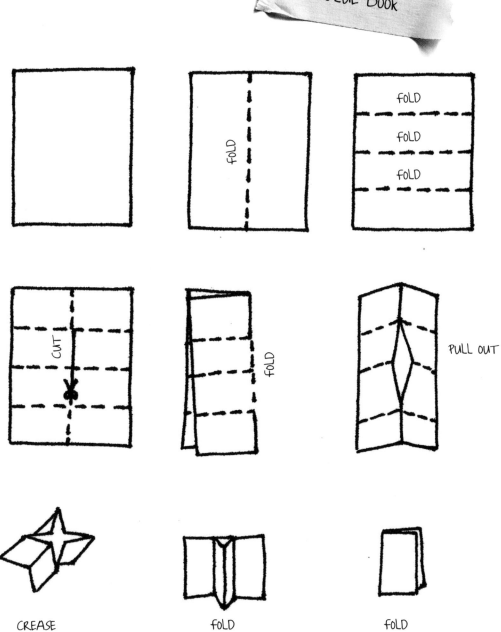

NO-GLUE BOOK

FOLD

FOLD
FOLD
FOLD

CUT

FOLD

PULL OUT

CREASE

FOLD

FOLD

DRIPS AND SPILLS

COFFEE OR TEA

PAINT IN COLD COFFEE
OR TEA USING EXISTING
MARKS AND SPILLS AS
YOUR STARTING POINT.

ADD TO THE SPILLS WITH A BRUSH
OR INSTRUMENT OF YOUR CHOICE...

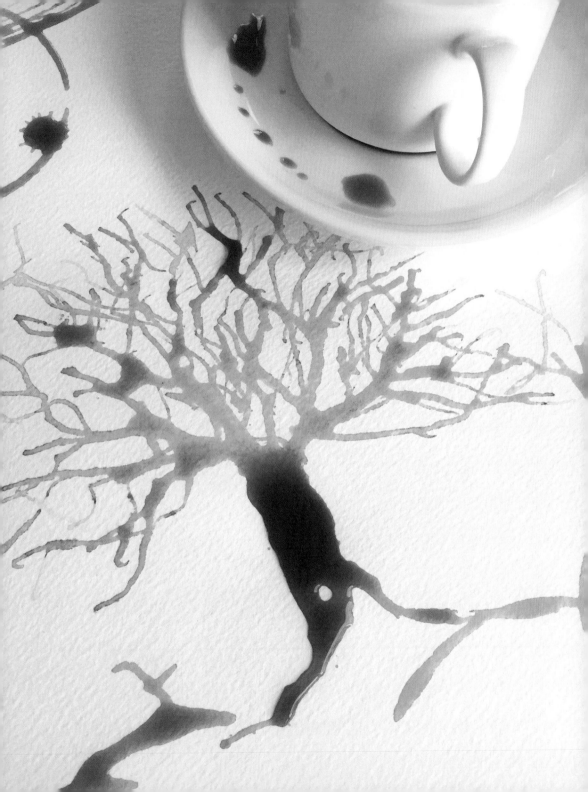

VARY YOUR TIPPLE! TRY RED FOR DEEP, RICH MARKS AND
ROSE FOR A DELICATE COLOUR. WHY NOT TRY DRAWING WITH
OTHER LIQUIDS SUCH AS HONEY, BEETROOT JUICE, TOMATO
SAUCE, ETC.

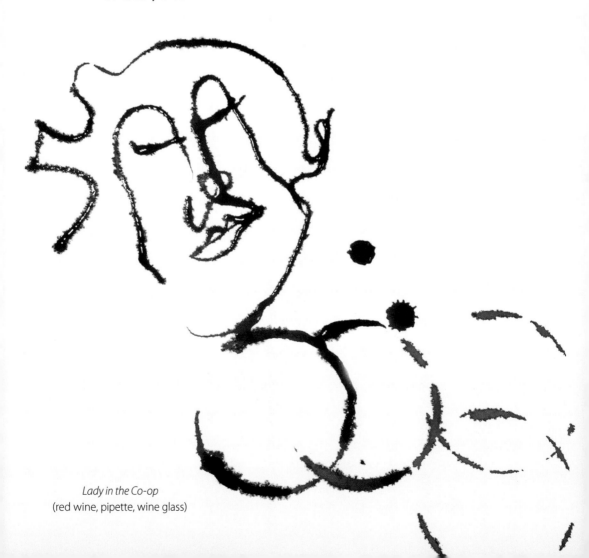

Lady in the Co-op
(red wine, pipette, wine glass)

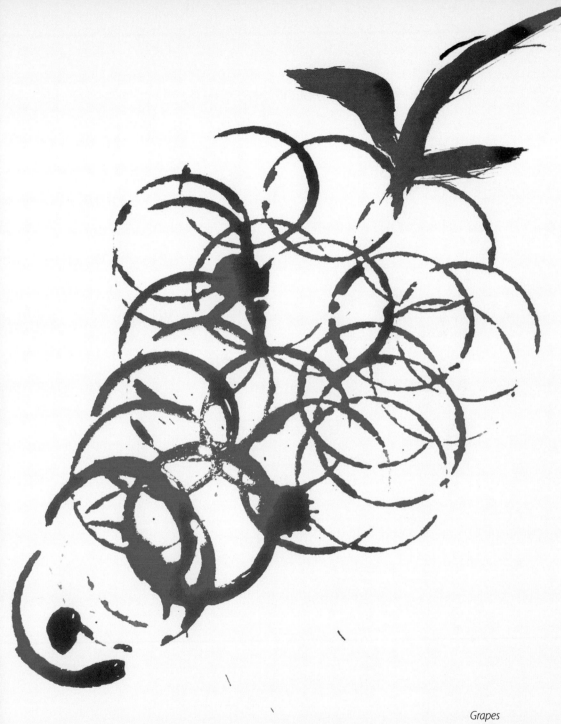

Grapes
(red wine, wine glass)

ARTIST'S INSPIRATION

ARTISTS WORTH EXPLORING:

<u>BODY ARTISTS:</u>
DAVID HAMMONS (1943-)
AHMED AL SAFI (1971-)
GU WENDA (1955-)

<u>COFFEE ARTIST:</u>
MICHAEL BREACH (1984-)
FABIENNE VERDIER (1962-)
GIULIA BERNARDELLI (1987-)

<u>TRACKS</u>
THOMAS YANG (1973-)

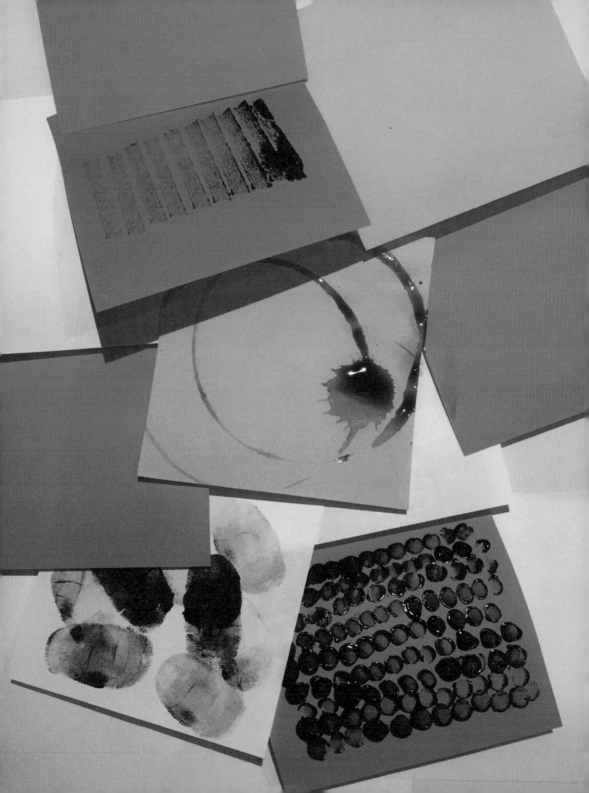

PAPER

PUTTING IT TOGETHER

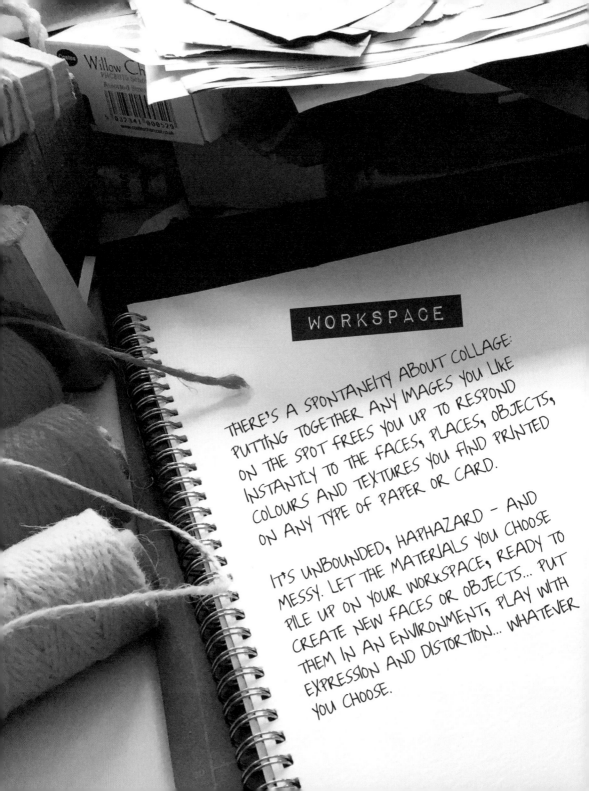

WORKSPACE

THERE'S A SPONTANEITY ABOUT COLLAGE: PUTTING TOGETHER ANY IMAGES YOU LIKE ON THE SPOT FREES YOU UP TO RESPOND INSTANTLY TO THE FACES, PLACES, OBJECTS, COLOURS AND TEXTURES YOU FIND PRINTED ON ANY TYPE OF PAPER OR CARD.

IT'S UNBOUNDED, HAPHAZARD — AND MESSY. LET THE MATERIALS YOU CHOOSE PILE UP ON YOUR WORKSPACE, READY TO CREATE NEW FACES OR OBJECTS... PUT THEM IN AN ENVIRONMENT, PLAY WITH EXPRESSION AND DISTORTION... WHATEVER YOU CHOOSE.

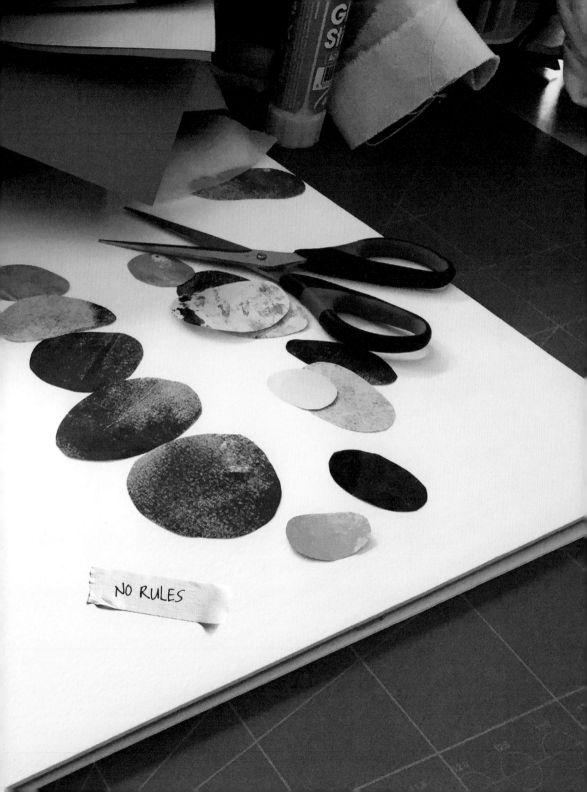

NO RULES

COLLAGE BASICS

* GATHER TOGETHER MAGAZINES AND NEWSPAPERS, AND ANY OTHER PRINTED MATERIALS YOU FIND: WALLPAPER OFFCUTS, JUNK MAIL OR OLD BIRTHDAY CARDS, BUS AND TRAIN TICKETS FROM COAT POCKETS, TILL RECEIPTS FROM SHOPPING BAGS, FOOD PACKAGING, COLOURED PAPER, TISSUE PAPER... WHATEVER YOU CAN LAY YOUR HANDS ON.

* SELECT THE IMAGES THAT APPEAL TO YOU, THEN CUT OR TEAR THEM OUT.

* PUT YOUR CUT-OUTS ON A LARGE PIECE OF PAPER ON YOUR DESK, THEN EXPERIMENT WITH THEIR POSITION. LOOK FOR COMPLEMENTARY SHAPES, COLOURS AND TEXTURES.

* BEFORE YOU START STICKING THE PIECES DOWN, TAKE A PHOTO OF YOUR COMPOSITION ON YOUR PHONE IN CASE ANYTHING MOVES BEFORE IT'S GLUED.

* STICK DOWN THE PIECES, STARTING FROM THE CENTRE AND WORKING OUT.

CREATING A CHARACTER

WHO DO YOU WANT TO CREATE? THINK ABOUT ATTRIBUTES;
YOU MIGHT BEGIN BY IMAGINING SOMEONE VERY UNLIKE YOU,
OR JUST THE OPPOSITE. IT COULD BE A PUBLIC FIGURE,
OR A PERSON YOU KNOW. LET THIS CHARACTER GUIDE
YOUR IMAGE CHOICES — USE LARGER OR BOLDER IMAGES
TO EXPRESS THE MOST DOMINANT ASPECTS OF THEIR
PERSONALITY. THINK OF YOUR IMAGES AS VISUAL CLUES
TO CHARACTER TRAITS.

TO HELP YOU SELECT IMAGES, ASK YOUR IMAGINED
CHARACTER A FEW QUESTIONS...

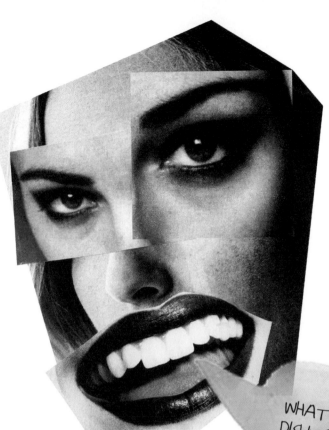

WHAT DO THEY LIKE OR DISLIKE? WHAT'S THEIR AGE AND LIFESTYLE? DO THEY PREFER INDOORS OR OUTDOORS? DO THEY HAVE HOBBIES? ARE THEY QUIET OR LOUD? DO THEY LIKE FASHION? ANIMALS? ...ETC.

My best friend
(magazine collage)

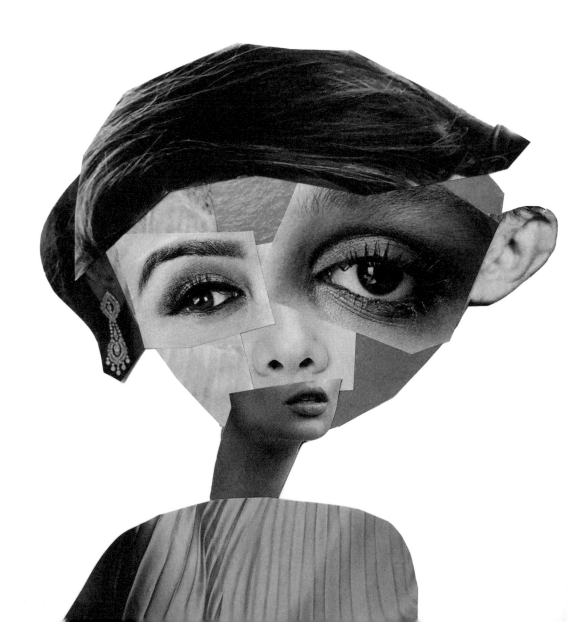

✱ FAVOURITE COLOUR: TURQUOISE
✱ LIKES: BEING OUTDOORS. NATURE, CALM SEAS
✱ STYLE: NEAT, SUBTLE, EXPENSIVE JEWELLERY
✱ PERSONALITY: SHY, QUIET, A GOOD LISTENER

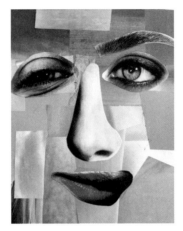 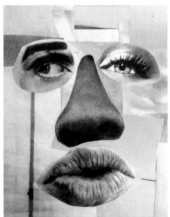

EMPHASISE EXPRESSIONS BY USING JUST ONE COLOUR
OR COLLAGE PIECES OF SIMILAR COLOURS FOR THE
BACKGROUND. WORK QUICKLY TO CREATE MULTIPLE
CHARACTERS - PLAY WITH DIFFERENT IMAGES AND
TEXTURES, THEN DISPLAY TOGETHER TO CREATE
A STRONG, SINGLE COMPOSITION.

Above: *Blue and Yellow*
Right: *All My Friends*
(magazine collage)

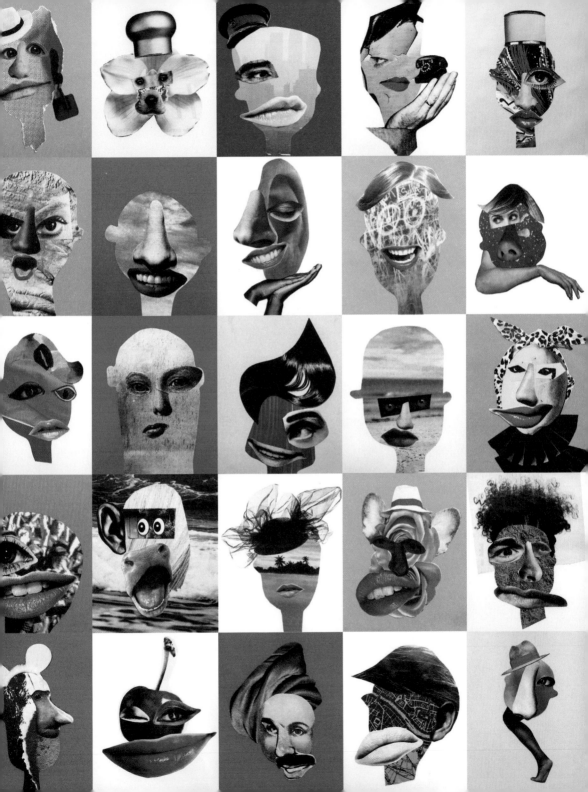

SETTINGS

WHAT SITUATION SUITS YOUR CHARACTER BEST?
PLACE YOUR FIGURE IN A SETTING THAT EXTENDS
THEIR PERSONALITY. YOU COULD INCLUDE FANTASY
LANDSCAPES AND REAL LANDMARKS, COSMIC SKIES
AND CITY PARKS: SEE HOW THE DYNAMIC OF THE
WHOLE IMAGE CHANGES WHEN YOU SET ELEMENTS
FROM DIFFERENT ENVIRONMENTS TOGETHER.
WHAT DOES THIS SAY ABOUT YOUR CHARACTER?

* FAVOURITE COLOURS: BLACK AND WHITE
* LIKES: TRAVELLING THE WORLD, TEXTILES, FASHION
* STYLE: SMART-GLAM. HEELS ESSENTIAL
* PERSONALITY: EXTROVERT

Right: *The Urbanite*
(magazine collage)

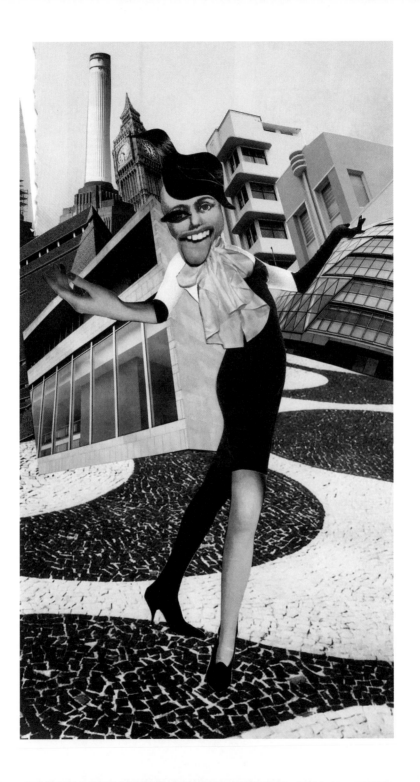

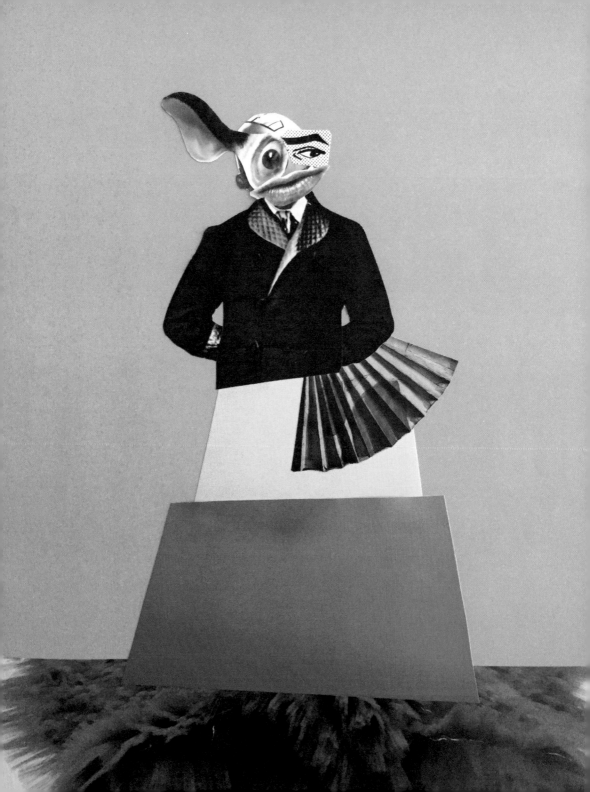

PLACE PATTERNED AND TEXTURED PIECES ALONGSIDE
FLAT, ABSTRACT SHAPES AND SEE HOW THE CONTRAST
MAKES THE PATTERN STAND OUT AND THE FLAT SHAPES
MORE MEANINGFUL.

THINK ABOUT COLOUR. WILL YOU GO FOR CLASHING,
ANALOGOUS OR COMPLEMENTARY?

BE BOLD. YOU DON'T NEED TO FILL ALL THE SPACE IN
YOUR COMPOSITION TO CREATE A POWERFUL STATEMENT.

SPACE = DRAMA AND CLARITY

Left: *Noel Howard*
(magazine collage)

FACIAL DISTORTION

WITH A SHREDDER, OR, TAKING A BIT LONGER, WITH SCISSORS OR CRAFT KNIFE, YOU CAN DISTORT AN OLD MAGAZINE IMAGE OR PRINTED PHOTO. ELONGATE THE FACE, TWIST AN EYEBROW OR TWO, AND ADD IMPACT TO A PARTICULAR FACIAL FEATURE...

STOP THE SHREDDER HALFWAY AND STICK MASKING TAPE ALONG THE CUT EDGE, TO KEEP ALL THE PIECES TOGETHER UNTIL YOU'RE READY TO ARRANGE THEM ON PAPER. FINISH THE SHREDDING, REMOVE FROM THE MACHINE AND PLACE ONTO A PIECE OF PAPER. CAREFULLY REMOVE THE TAPE AND ARRANGE YOUR COMPOSITION.

Right: *Mr*
(shredded collage)

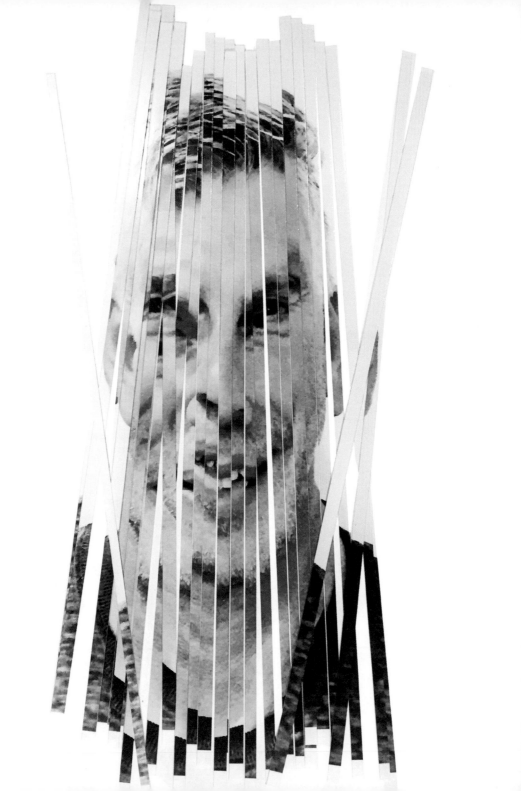

Shout
(sliced collage)

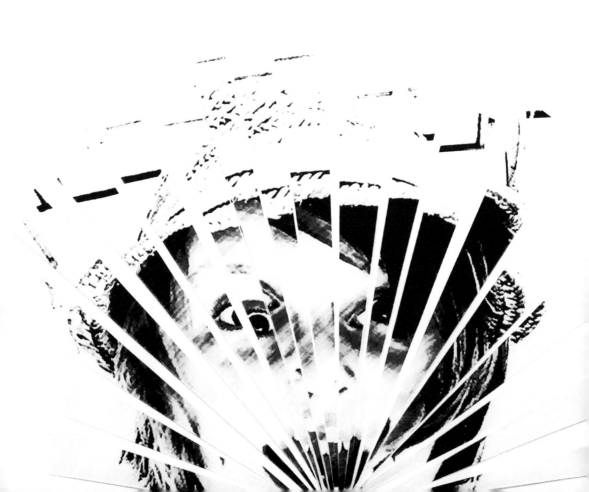

CREATE A NEW FOCAL POINT IN AN IMAGE – IN A
PORTRAIT, PERHAPS IT'S THE MOUTH, AS SHOWN OPPOSITE,
TO SUGGEST THAT THE CHARACTER IS SHOUTING. USING
A RULER AND CRAFT KNIFE ON A CUTTING MAT, CUT
FROM YOUR CHOSEN FOCAL POINT. WHEN YOU'RE DONE,
MOVE THE CUT PIECES ONTO PAPER. PLAY WITH THE SPACE
BETWEEN THE CUT PIECES AS THE PROCESS TRANSFORMS
THE IMAGE.

ADDING MEDIA

CUSTOMISE YOUR COLLAGE BY ADDING HAND-DRAWN
ELEMENTS - EXPERIMENT WITH CHARCOAL, PAINT,
PEN AND INK, PENCILS, PASTELS... BRING IN SHADING,
SMUDGING, OR FINE DETAIL WITH LINES AND PATTERN.

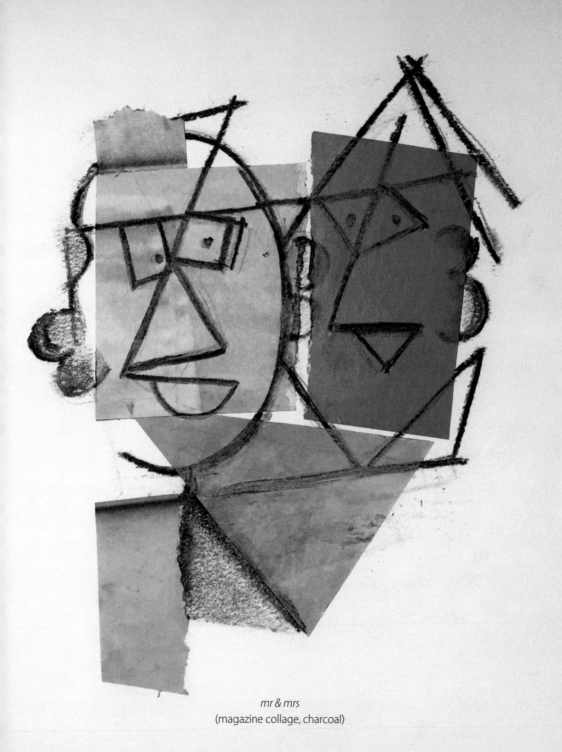

mr & mrs
(magazine collage, charcoal)

YOU CAN ALSO ADD IN PRINTED PHOTOGRAPHS OF QUIRKY STUFF YOU'VE MADE - LIKE MELTED PLASTIC BAGS.

IRON RANDOMLY PLACED PIECES OF PLASTIC CARRIER BAGS ONTO TAUT FABRIC. IRON THE PIECES FACE DOWN THROUGH GREASEPROOF PAPER. THE PLASTIC ADHERES TO THE FABRIC, GIVING YOU COLOURFUL ABSTRACT SHAPES AND OVERLAPPING LOGOS. PHOTOGRAPH, PRINT OUT AND ADD TO YOUR COLLAGE.

THE BAGS: THE THINNER - THE CHEAPER - THE BETTER...

COLLAGE PATTERNS

FOCUS ON TEXTURE WHEN COLLAGING PATTERNS, USING FOUND IMAGES AND COLOURED PAPERS. SHAPE THEM AS YOU LIKE, CHOOSING COLOURS THAT CONNECT WITH YOUR THEME OR SHAPING THE DESIGN AROUND THE IMAGES YOU'VE FOUND.

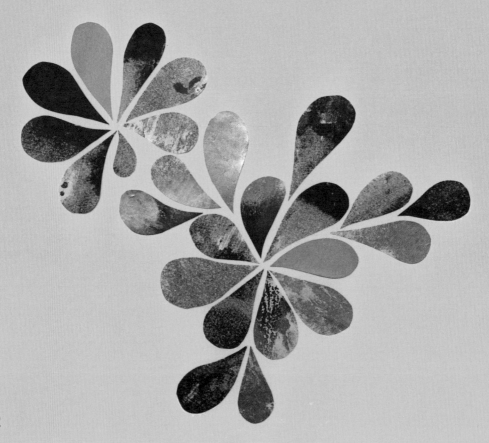

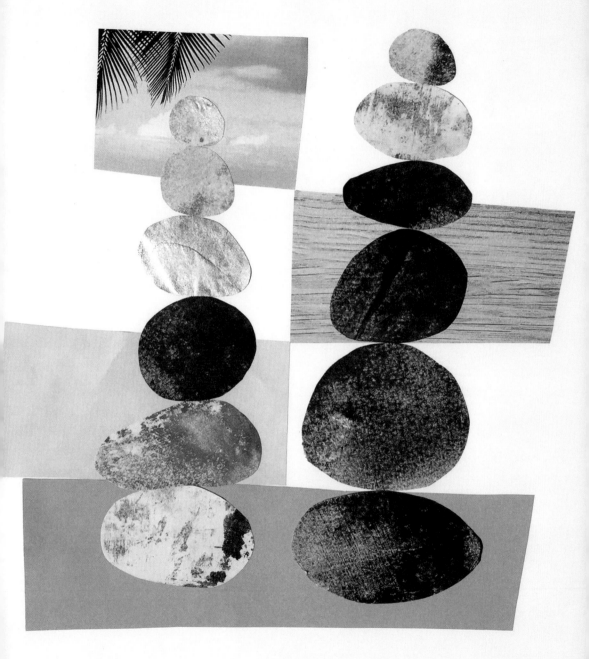

Palm Island
(printed texture, coloured paper and magazine collage)

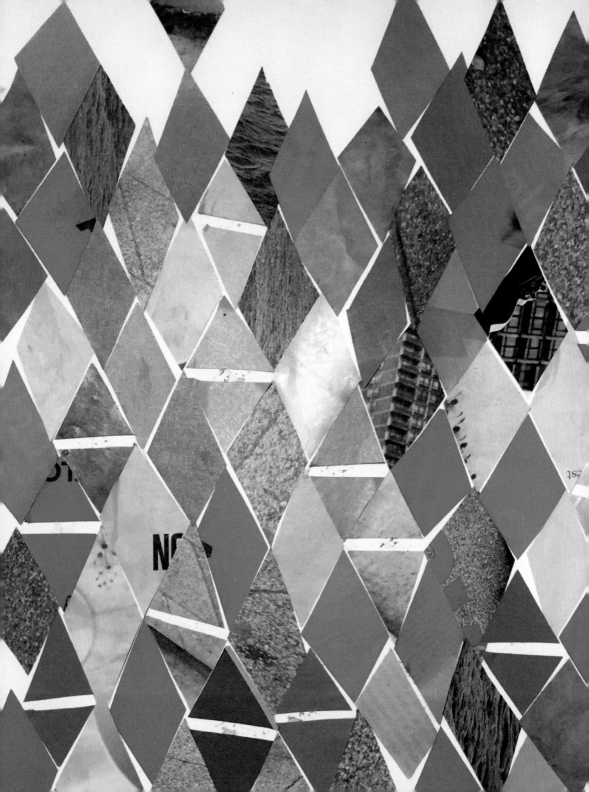

CREATE YOUR OWN REPEAT PATTERNS.

TRY EXPERIMENTING WITH COMPLEMENTARY OR CLASHING
COLOURS IN LINEAR OR STACKED ARRANGEMENTS.

3D COLLAGE

YOU CAN CREATE A THREE-DIMENSIONAL EFFECT BY ARRANGING CAREFULLY SELECTED PIECES IN GEOMETRIC DESIGNS. CONTRASTING LIGHT AND DARK SURFACES WILL ADD DEPTH. VARY YOUR BACKGROUND TO COMPLEMENT YOUR PATTERN USING PAPER OR FABRIC.

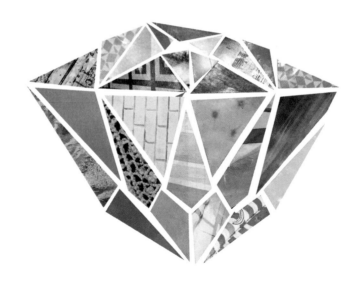

Diamond
(printed texture, coloured paper and magazine collage)

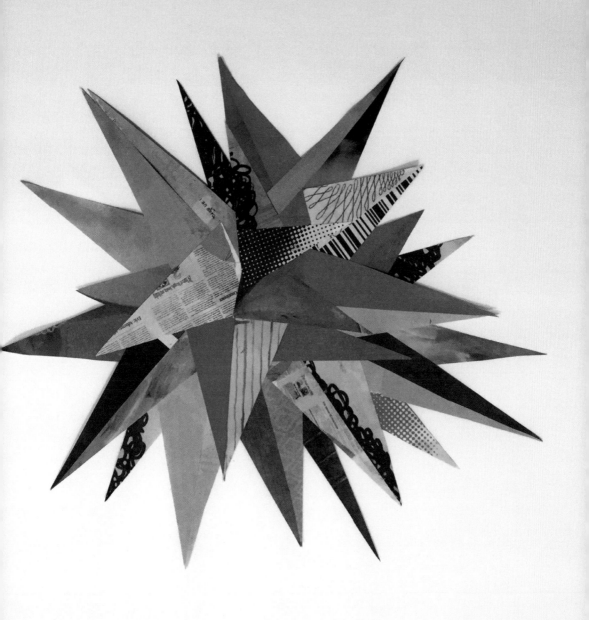

Star
(printed texture, coloured paper and magazine collage)

CREATE THREE-DIMENSIONAL ARTWORKS BY LAYERING SIMPLE COLLAGED SHAPES. CUT YOUR SHAPES OUT OF CARDBOARD, APPLY COLLAGE TO THE SURFACES, ADDING COLOUR AND TEXTURE, THEN ASSEMBLE THE PIECES. ADD SPACERS MADE FROM FOLDED CARD BETWEEN EACH LAYER, SECURING WITH GLUE OR MASKING TAPE, FOR DEPTH. EXPERIMENT WITH DIRECTIONAL LIGHTING, AND CAPTURE IN PHOTOGRAPHY.

RIGHT:
CONSTRUCTED IN THREE LAYERS - BACKGROUND, MIDDLE LAYER AND FOREGROUND.

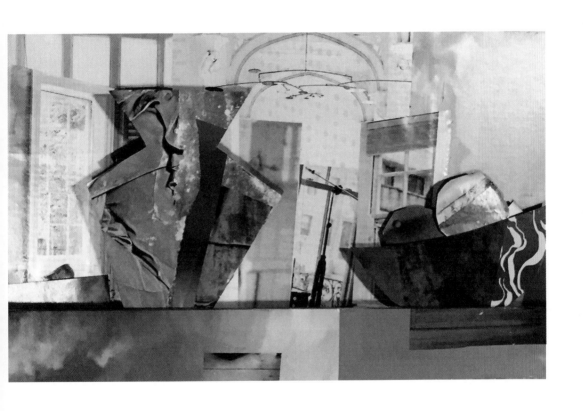

Art Life, Still Life
(printed texture, coloured paper and magazine collage)

ARTIST'S INSPIRATION

WORTH EXPLORING:

<u>COLLAGE ARTISTS:</u>
PICASSO (1881-1973)
KURT SCHWITTERS (1887-1948)
HANNAH HOCH (1889-1978)
MAN RAY (1890-1976)
JOSEPH CORNELL (1903-1972)
RICHARD HAMILTON (1922-2011)
NANCY SPERO (1926-2009)
ERIC CARLE (1929-)
JOHN STEZAKER (1949-)
KYLE MOSHER (1985-)

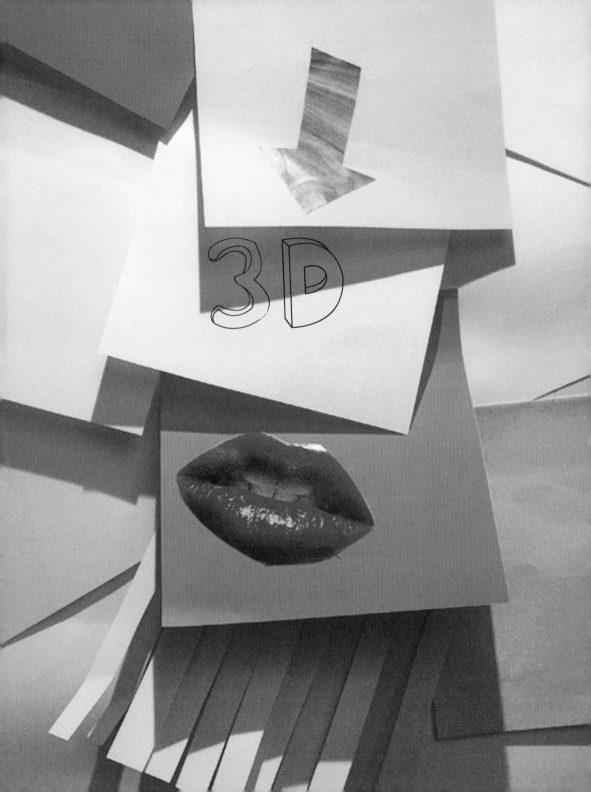

IMAGE CREDITS

ALL ARTWORKS BY BEV SPEIGHT UNLESS OTHERWISE SPECIFIED.

ALL PHOTOGRAPHY BY BEV SPEIGHT EXCEPT FOR DAVID MIDGLEY ON PAGES 11, 28, 38, 39, 44, 45, 64, 65, 70, 79, 116, ALFIE MCMEEKING ON PAGES 56, 57, 59.

THANK-YOUS

A BIG THANKS TO THESE LOVELY PEOPLE FOR MAKING THIS BOOK POSSIBLE - IN NO PARTICULAR ORDER...

MY AGENT, CHELSEY FOX, FOR HER SUPPORT AND GUIDANCE; LIZ DEAN, MY DEAR FRIEND AND CONTRIBUTING WRITER; DAVID MIDGLEY FOR HIS SUPPORT, PATIENCE AND MARVELLOUS PHOTOGRAPHY; THE TALENTED CONTRIBUTING ARTISTS: ARCHIE MIDGLEY, ALFIE MCMEEKING, CATH SPEIGHT, DAVID MIDGLEY, DOMINIC JAMES, SADIE JONES, HOLLY HAMILTON, SOL PLATT, DAISY PLATT AND AMBRIN KAZI; THE WONDERFULLY CREATIVE TEAM AT ILEX - ROLY ALLEN, ZARA LARCOMBE, JULIE WEIR, FRANK GALLAUGHER, MESKEREM BERHANE AND RACHEL SILVERLIGHT; AND MY TRULY WONDERFUL PARENTS, BRENDA AND TONY SPEIGHT, TO WHOM I AM DEDICATING THIS BOOK.

ABOUT THE AUTHOR

I AM PASSIONATE ABOUT ART. A GRAPHIC DESIGNER, ILLUSTRATOR AND ART EDUCATOR, I STARTED OUT AT LONDON DESIGN AGENCY MICHAEL PETERS, THEN WORKED FOR THE BBC AND HARPERCOLLINS PUBLISHERS BEFORE CO-FOUNDING DESIGN PARTNERSHIP XAB. NOW AN INDEPENDENT CREATIVE, MY PROJECTS INCLUDE CORPORATE IDENTITY, BRANDING AND PROMOTIONAL DESIGN, BOOK ILLUSTRATION AND PHOTOGRAPHIC ART DIRECTION.

FOR THE LAST FIVE YEARS I'VE BEEN WORKING WITH YOUNG STUDENTS AT THE NATIONAL ART AND DESIGN SATURDAY CLUB IN LONDON, WHICH OFFERS A SIMILAR STRUCTURE TO THE PRE-BA ART FOUNDATION COURSE I TEACH AT MIDDLESEX UNIVERSITY. THE PROJECTS I DESIGN FOR THESE WORKSHOPS EMPHASISE RESEARCH, COLLECTING, EXPERIMENTATION AND BEING INSPIRED, SO CREATIVITY FLOWS - AND IT BECOMES FUN.

FEEDBACK FROM PARENTS, ASKING IF THERE WAS A SIMILAR COURSE OPPORTUNITY FOR ADULTS, INSPIRED ME TO WRITE THIS BOOK. I LOVE GUIDING OTHERS TO EXPLORE THE WORLD AS ARTISTS, AND TO CREATE WORK THAT THEY MAY NEVER HAVE EXPECTED FROM THEMSELVES.